watercolour secrets

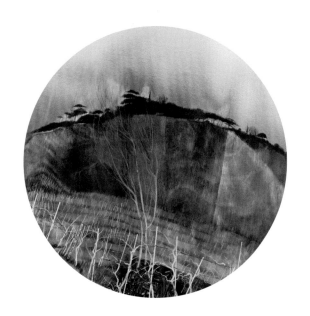

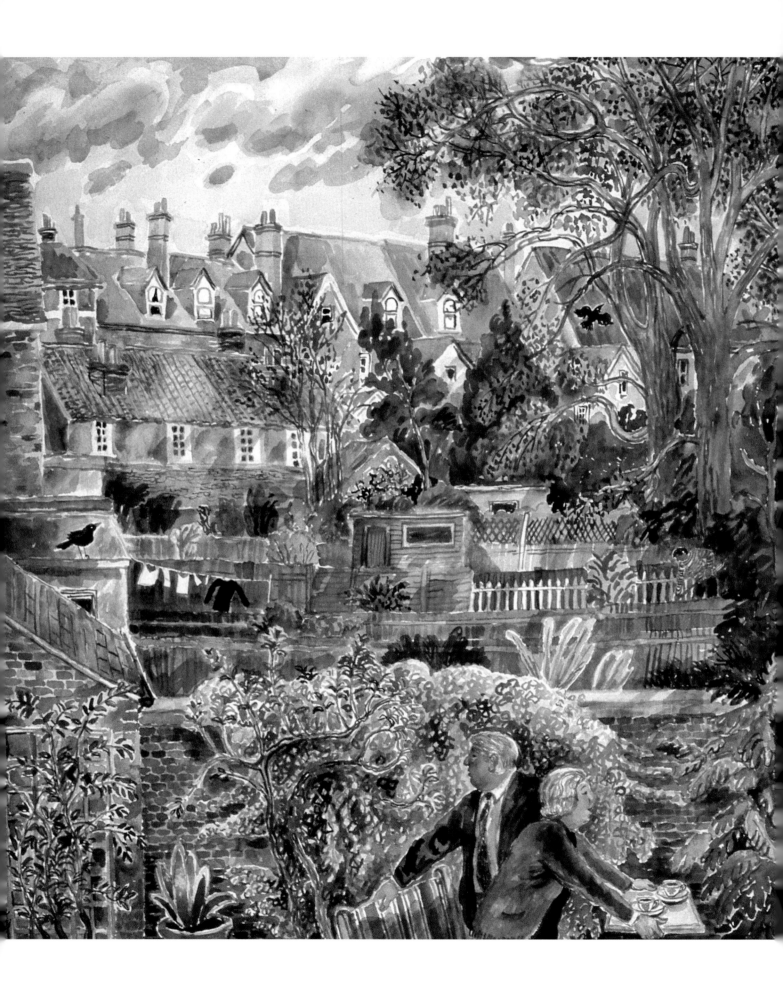

watercolour secrets
jill leman and the
Royal Watercolour Society

Bloomsbury Visual Arts
An imprint of Bloomsbury Publishing Plc

BLOOMSBURY
LONDON · OXFORD · NEW YORK · NEW DELHI · SYDNEY

Bloomsbury Visual Arts

An imprint of Bloomsbury Publishing Plc

50 Bedford Square
London
WC1B 3DP
UK

1385 Broadway
New York
NY 10018
USA

www.bloomsbury.com

Bloomsbury and the Diana logo are trademarks of Bloomsbury Publishing Plc

First published in 2014
Reprinted in 2015

British Library Cataloguing-in-Publication Data
A catalogue record for this book is available from the British Library

ISBN: PB: 978-1-4081-8427-1

Typesetting and layout: Susan McIntyre
Printed and bound in China

Frontispiece: **June Berry,**
Tea in the Garden 1995 watercolour 56 x 59cm

Contents

Diana Armfield, Fay Ballard, Charles Bartlett, Richard Bawden, June Berry, Akash Bhatt, Dennis Roxby Bott, Francis Bowyer, William Bowyer, David Brayne, Liz Butler, Michael Chaplin, Helga Chart, Michael Collins, Jane Corsellis, Clare Dalby, Alfred Daniels, George Devlin, John Doyle, Jim Dunbar, Anthony Eyton, James Faure Walker, Sheila Findlay, David Firmstone, Tom Gamble, Janet Golphin, Isla Hackney, Charlotte Halliday, Susan Hawker, Julie Held, Bill Henderson, Sarah Holliday, Ken Howard, Jonathan Huxley, Wendy Jacob, Olwen Jones, Janet Kerr, Sophie Knight, Karolina Larusdottir, Sonia Lawson, Jill Leman, Martin Leman, Arthur Lockwood, Caroline McAdam Clark, Angus McEwan, Colin Merrin, Michael Middleton, Bridget Moore, Peter Morrell, Alison C. Musker, John Newberry, Paul Newland, Barry Owen Jones, David Paskett, David Payne, Simon Pierse, Richard Pikesley, Geoffrey Pimlott, Neil Pittaway, Thomas Plunkett, Saliann Putman, Peter Quinn, Mark Raggett, Stuart Robertson, James Rushton, Denis Ryan, William Selby, Agathe Sorel, Richard Sorrell, Janet Q. Treloar, Alexander Vorobyev, Ann Wegmuller, Jenny Wheatley, Michael Whittlesea, Annie Williams, Charles Williams

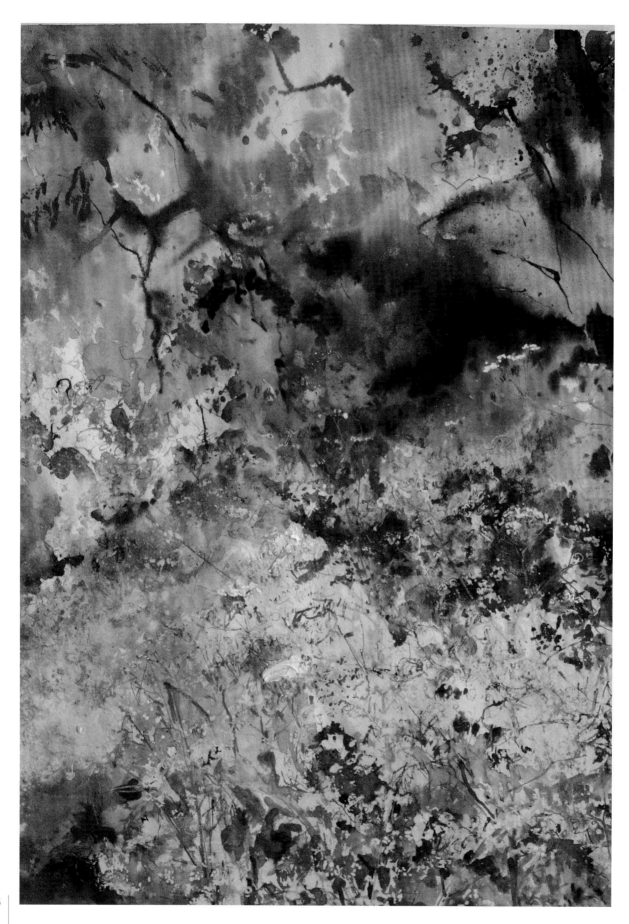

Foreword

In this book seventy-six members of the Royal Watercolour Society (myself included) each describe their individual approach to their work. Although we all use similar materials, every single result is totally different and so this book provides a fascinating insight into the ways in which contemporary artists resolve the practicalities of picture-making.

The Royal Watercolour Society and I have had a long and happy association – I have been a member since 1979 and am delighted that while we can look back over the 210 years of the RWS and be proud of the Society's achievements, we can also celebrate the RWS today and look forward to, at least, another 210 successful and fulfilling years.

I am quite sure this book will be of great interest to the general reader as well as to artists, and everyone who is interested in discovering more about the Royal Watercolour Society in the twenty-first century.

Professor Ken Howard OBE RA

Royal Watercolour Society artists constantly challenge the stereotypes and orthodoxies of watercolour painting. In their handling of the medium, the RWS artists show that painting in watercolour has a vibrant and assured future as certain as its illustrious past. History has shown that each generation of artists reinvents this fluid, innovative and challenging of media to create paintings that are compelling, innovative and a joy to behold.

Members of the Royal Watercolour Society, whether they are abstract or figurative painters, share a common respect for the excitement of the process of painting. As you turn the pages of this book you will read first-hand accounts by RWS artists about the unlimited possibilities open to painters working in water-based media today.

President Thomas Plunkett PRWS
President of The Royal Watercolour Society

Sophie Knight RWS, Summer Bursts of Cow Parsley
2012 watercolour & bodycolour 76 x 56cm

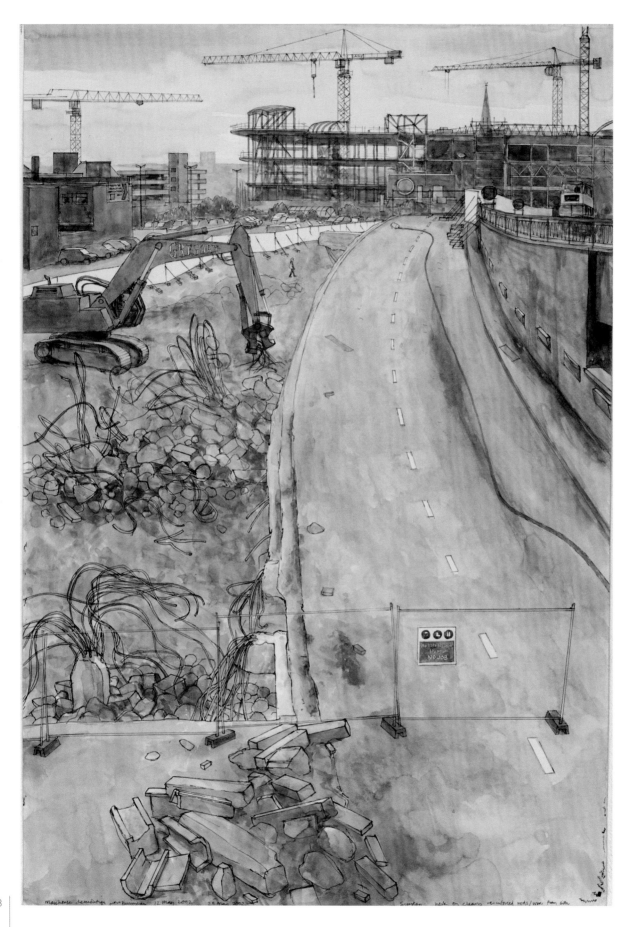

Manchester demolition near Bullring 12 May 2002 28 May 2002 Scanlon hole on clears reinforced rods/wire from site

Acknowledgements

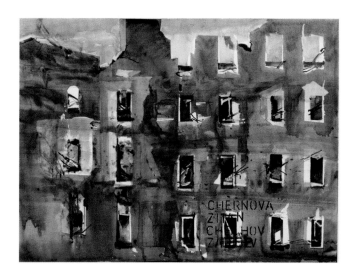

First I must thank all the RWS artists who have contributed to this book. It is not easy to put into words how the process of creating art happens, but they responded magnificently.

The fact that the RWS, founded in 1804, is still a thriving and solvent society is due to the many members over the years who ensured our future, so thank you to them. Thanks also to Thomas Plunkett, President of the RWS and Wendy Jacob, Vice-President, who have been enthusiastic and supportive throughout this project.

The RWS is very fortunate to have its base at the Bankside Gallery and I would like to thank all the staff there, especially Angela Parker, Gallery Director, who showed me *Printmakers' Secrets* which Anthony Dyson had put together in 2009, and suggested the RWS might do something similar; and Katerina West, RWS Secretary: her organising skills and attention to detail have been invaluable.

At Bloomsbury Publishing, Davida Forbes first saw the possibilities for a book and has patiently and productively fielded all my queries and concerns.

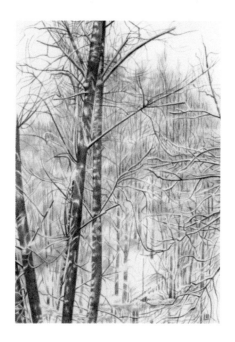

Left: **Arthur Lockwood RWS, Demolition of Inner Ring Road, Birmingham** 2002 pen & wash 42 x 61cm

Top: **Janet Q. Treloar RWS, The Burnt Out Factory, Stalingrad** 2005 watercolour 55 x 74cm

Above: **Liz Butler RWS, Snowfall in the Park** 2011 watercolour 12.25 x 8.25cm

Introduction

In 1804 a group of artists formed 'The Society Associated for the Purpose of Establishing an Annual Exhibition of Paintings in Water Colours'. Their first exhibition in Brook Street, London W1 became a 'must see' event for fashionable London and the Royal Watercolour Society (RWS) was born.

In 2014 we are still here, in our own gallery at Bankside – the south side of the Thames in London. The society is limited to 75 full members (RWS) and unlimited Associates (ARWS). New Associate Members are elected annually by other Members of the Society – and it is an honour to be able to put ARWS after your name. You may have to wait several years before becoming a full member.

In July 2012, I wrote a letter to all the Members and Associates of the RWS inviting them to participate in this book and to write, in their own words, about any aspect of their practice that they chose. I suggested a few questions that, as an artist, I am often asked: What images inspire you? Where do ideas come from? How do you start? How do you know when a painting is finished? How do you keep going? Do you have favourite materials?

The 76 RWS Members and Associates who responded are from diverse backgrounds and a wide range of different experiences but they all use water-based media either solely or as part of their practice. This includes watercolour, gouache, acrylic, ink or tempera. The RWS accommodates, encourages and exhibits these

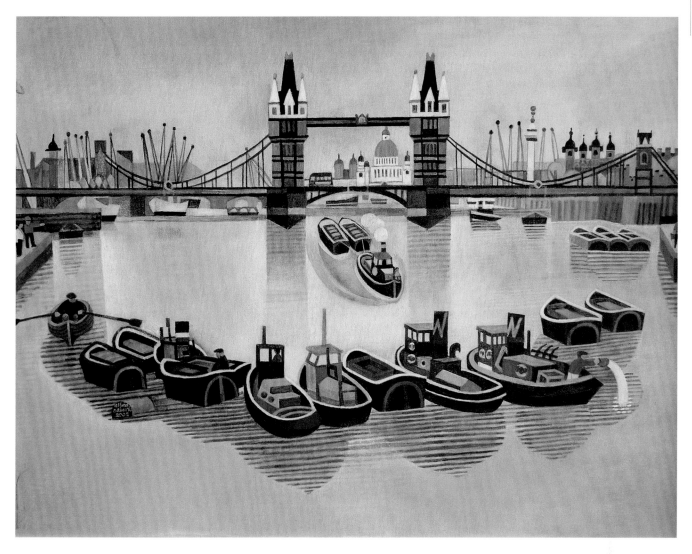

Left: **John Newberry RWS, Rain, East Street** 2012
watercolour 23.2 x 32.4cm

Above: **Alfred Daniels RWS, Tower Bridge** 2011
acrylic 46 x 61cm

Right: **Jill Leman RWS, Tulips in a Willow Pattern
Jug** 2010 watercolour & acrylic 58 x 62cm

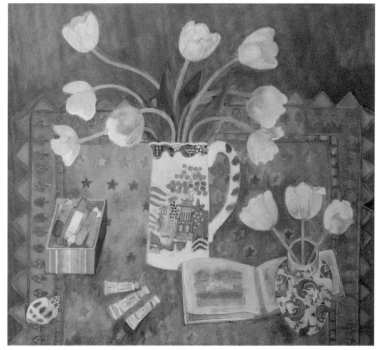

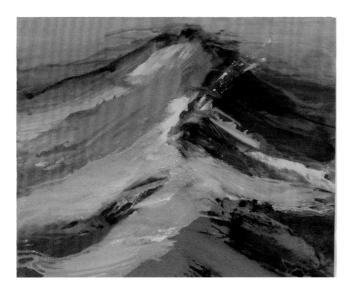

Isla Hackney RWS, Autumn Evening in the Mountains 2006 acrylic 75 x 89cm

Jenny Wheatley RWS, Dog With Aspirations watercolour 86 x 104cm

diverse contemporary artists. Our exhibitions show pieces that cover the full range of art from photo-realism to abstract, from landscape to expressionism, from dreams and memories to detailed recordings of reality.

While reading their copy for this book I realised fully what an interesting and talented collection of artists the members of the RWS are, and all very different. Amongst the Members there are artists who plan every step of a painting and artists who launch bravely into the void. We have Members who use only their favourite paper, while others will use card, cardboard, rough or smooth paper or whatever is to hand. To some, drawing is a daily practice; to others photography as reference is vital. Traditional sable 'watercolour' brushes may be used but so are brushes made from acrylic fibre, household paintbrushes, scrubbing brushes, sponges, rags and sprays. The paint may be brushed, sponged, sprayed or poured onto the support. Inspiration may come from memory, travel, buildings, places, people, the city or landscape and much, much more.

Many RWS Members have held or currently hold lectureships or teaching roles and are able to pass on their expertise; others communicate through their work alone. Many are engaged in this kaleidoscope of creative activity as well as producing their own work. We have Members who have trained and worked as textile designers, graphic designers, illustrators, mural painters, printmakers, sign writers and animators, as well as in the fine art departments of art schools.

Each artist is on a quest with a most important goal: to find their own voice in the turmoil of the world today and to produce visually exciting work. The creative process continues to fascinate and this book contains accounts of many different ways of seeing and producing; there may be secrets but there are no rules: whatever works.

Jill Leman, RWS

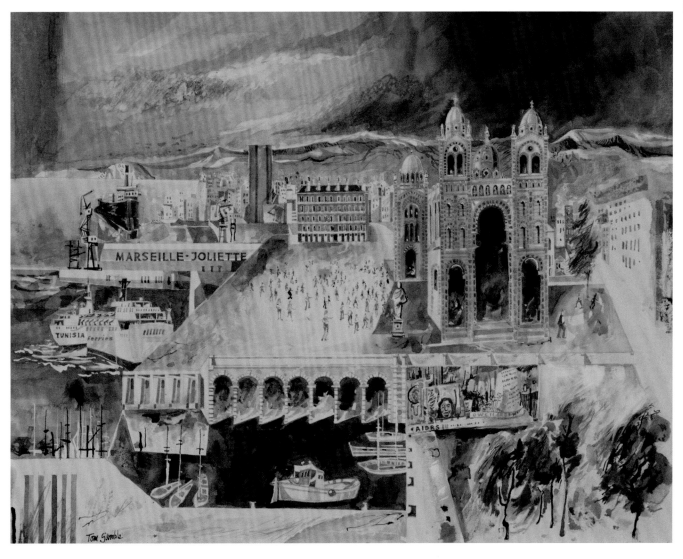

Tom Gamble RWS, Le Marseille de la Famille Bonnet 2010 watercolour 53 x 41cm

Michael Collins ARWS, Day of Rapture 2012 acrylic & gouache 38 x 50cm

Peter Morrell RWS, Dartmoor, Autumn c.1974 watercolour 12.5 x 17cm

Diana Armfield

What gives me that urge to draw or paint? I think any experience in our family life that I have enjoyed, loved or admired, that I can interpret visually. Much that we took for granted is threatened and needs to be cherished and honoured. I want to hold on to these experiences and share them with others. I am thinking of land, sea and peopled townscapes, flowers and places where people gather to be convivial; long lunches, picnics, galleries, concert halls and cathedrals, to mention just a few. I have found that no matter how I arrive at my subject, the act of interpreting in paint or drawing makes it significant; that particular view, whether it is just a pencil outline of a mountain slope or a well-considered watercolour, will always mean more to me than it did before.

Left: **Lambing Time** watercolour, gouache & pastel
16 x 21.5cm

Right: **Conversation in Piazza Navona, Rome**
watercolour, gouache & pastel 24 x 16cm

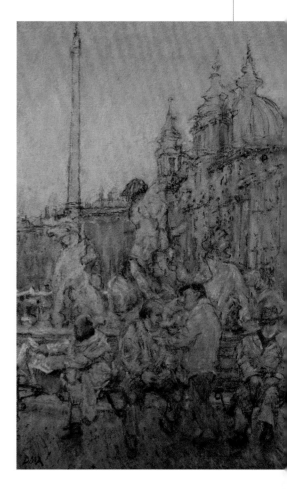

Some experiences are turned into paint directly, others, now we are in our nineties, are from memories of painting trips abroad, sparked off from old sketchbooks. Watercolour and gouache seem to lend themselves to these memory images, but so also do present-day Welsh landscapes with sheep!

I have accumulated watercolour paper over the years, of many different kinds, and the differing surfaces have a marked influence on the outcome, either helping or frustrating my efforts. I like a paper that is heavy enough not to need stretching, one that takes the initial drawing sweetly.

I often set out with the intention of keeping the drawing very simple, just there to guide my watercolour, but another sequence can easily happen instead. I become so absorbed by the drawing that it evolves into something too dark and complex for the watercolour to properly take over. I turn to gouache, which can dominate, and the work then develops into something richer, but I've lost my watercolour with it and perhaps a little of the luminosity.

Next to me on the drawing table is the big open box of pastels and before long I'm reaching out for a stick of pastel to breathe light into the gouache; the work has taken on a new aspect. The original elements are there but the language has changed. It may well turn again if I'm not satisfied, back to gouache, or even under the tap to be started again with watercolour over a mere shadow.

I began with a career designing fabrics and wallpaper, which alerted me to the rhythms and patterns in nature. I was turned to painting by circumstances of teaching drawing for painting at The Byam Shaw Art School, and never looked back. I had always admired the touch in paint of my husband, Bernard Dunstan. The handwriting of his painting revealed so much about himself and his subject, and still does. I was thrilled to find myself working in a medium that seemed to demand the development of handwriting. This might be both conscious and unconscious, but is inevitably personal and the very brushstroke of which it is made has to have an abstract life of its own, contributing to the build of meaningful shapes.

What I aim at in all my work stems back to childhood. My mother created, from four acres of untouched difficult gravel and sand soil, a garden, areas of field, flowers, grass-scrub and orchard that to me were a completely satisfying world. I think I absorbed unconsciously the principles by which that garden matured into something so deeply fulfilling. It is those principles that I hope underlie my work. There were linked divisions made by yew, lime and oak making a stable framework. Against this almost formal design played a waywardness from the things that grew; vistas, secret places, surprises and mysterious corners, all together making a welcoming background for people and animals.

When I am composing from drawings or looking for the composition on the spot, I have these principles of contract and contradiction in the not-so-back of my mind. I want to give the spectator enough clues to read the work, but hide enough to be revealed later. I want to find the geometry in the scene, have it there in the work, but break into or disguise it. In fact, one might say that for every solid statement of tone, shape or colour, I'll look for something counter. Of course I am overstating this. A lot of painting is following what is on offer and trying to get it right! There again is a contradiction which is part of the magical, difficult medium of watercolour.

Fay Ballard

My training took several paths: the City Lit taught
me to draw and paint from observation and from
the imagination and its Foundation Diploma
covered painting, printmaking, video, sculpture,
textiles and drawing as well as technical skills such
as colour theory and perspective. At the Chelsea
Physic Garden, the Diploma in Botanical Painting
enabled me to specialise in drawing and painting
plants from life. We spent days learning to control
the flow of watercolour paint with our sable brushes,
and attempting to draw a leaf accurately. There were
many false starts, setbacks and disappointments but
slowly, it all started to come together.

Left, top: **Radiccio** 2011 watercolour 30 x 30cm

Left, below: **Family** 2006 watercolour 132 x 96cm

Right: **Leaves** 2011 watercolour 45 x 37cm

The most valuable part of my MA in Fine Art at Central St Martin's Art School was the emphasis placed on theory and ideas. We were encouraged to keep a journal recording our thoughts, influences, inspirations, and things we liked or disliked. Every so often, I would draw a mind-map of my ideas, and when I look back over these journals now, I can see the key threads running through them. We presented work to our peer group regularly, and although daunting and adversarial, this was a useful exercise to help clarify thoughts, or resolve problems. Today, I write in my journal, keep an A4 sketchbook to rough out ideas, and rely on friends to give honest feedback.

After completing my training in 2006, I became absorbed making plant portraits from observation, as a vehicle for exploring my unconscious emotions. I was interested in the numinous, and friends often remarked that my work had an uncanny quality, as if the plants were alive or charged. I was reading Freud's theories on the uncanny as well as Rudolf Otto's book *The Idea of the Holy* and Kant's essay on the sublime. Dürer and Edward Burra were inspirations.

Dedication and perseverance are vital, but so, too, is luck. I was fortunate to be invited, along with others, to paint the plants at Highgrove for HRH the Prince of Wales who wanted to create a florilegium under the auspices of the Prince's Foundation. A series of exhibitions and a publication followed, which presented the opportunity to see the variety of responses to the project from artists throughout the world. The early support of Dr Shirley Sherwood, the pre-eminent collector of botanical art, has also been invaluable, enabling me to exhibit in several countries.

My working method involves finding suitable specimens, making rough drawings, and finally, a delicate outline pencil drawing (HB or B sharp pencil) on stretched hot-pressed Arches or Fabriano paper (300gms). A faint tea-wash is applied over the drawing, then the lights and darks are modelled, and detail added. Sometimes, I blot out colour with a paper towel to achieve highlights. I use fine-pointed sable brushes (Series 7, Kolinsky Winsor & Newton sizes 4 to 6). I prefer a restricted palette and semi-translucent colours: French Ultramarine, Schmincke Lemon Yellow or Winsor Yellow, Magenta, Raw Sienna and Burnt Sienna. I work on a table in my house in silence.

More recently, I have become interested in family history, and memory. My current work focuses on my childhood. The rules and conventions of botanical art have receded in favour of a more personal style. Pictures come from conscious and unconscious thoughts as a direct response to my feelings. I look through old family photographs, handle family treasures, and use my memory to make sketches in my book and notes in my journal. Reading autobiographies and revisiting family places might spark an idea or memory. Sometimes, I work on large pieces of Arches taken from a roll (pinned to a wall), and I might introduce other media, for example, crayons, charcoal, glue, tissue paper and thread.

Finally, I believe it is most important to be authentic, that is, to find your distinctive voice.

Charles Bartlett

I was born in Grimsby on the north-east Lincolnshire coast, and after the premature death of my father the family moved to Eastbourne on the Sussex coast. From the age of seven to my mid-teens, outdoor pursuits played a significant part in my life. The freedom of long bike rides and trips out to sea with the local fishermen were an important part of my development.

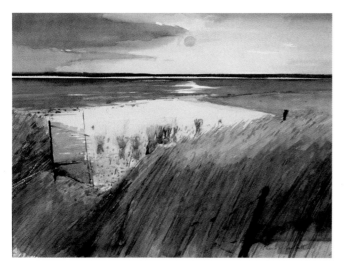 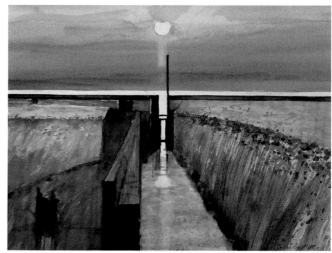

I attended the Grammar School and then Eastbourne College of Art. Eric Ravilious had been a student there before me and there was a strong tradition of landscape drawing and painting, working out on location, weather permitting. I became interested in etching and was well taught. At eighteen I won a scholarship to the Royal College of Art, but deferred my place till the war was over. Six years later, four of which were spent as a soldier, I finally became a student of the Royal College in 1946. Many of us ex-servicemen were far more mature than the pre-war intake. We were eager, serious and hardworking.

After three years in the engraving school, tutored by Malcolm Osborne and Robert Austin, I won a fourth year which I spent mostly painting. I had by then begun to find my direction and maybe because of my early influences I was attracted to wild places. The rivers, creeks, saltings and marshland of East Anglia became my spiritual home. Buying a small wooden boat which I repaired and fitted out for sailing meant I spent much of my free time on the Essex coast. I explored the sea walks, absorbing this unique landscape and all the time making sketches and notes. It was becoming my own personal experience, observing its changes and moods, the tide in ebb and flow.

After graduation I took any freelance illustration work that could be had, together with some part-time art-school teaching. I was still living in London, and continued to spend time on the east coast, developing my ideas and sailing my boat.

Travelling to far and exotic places has never appealed to me; I am very much a northern European

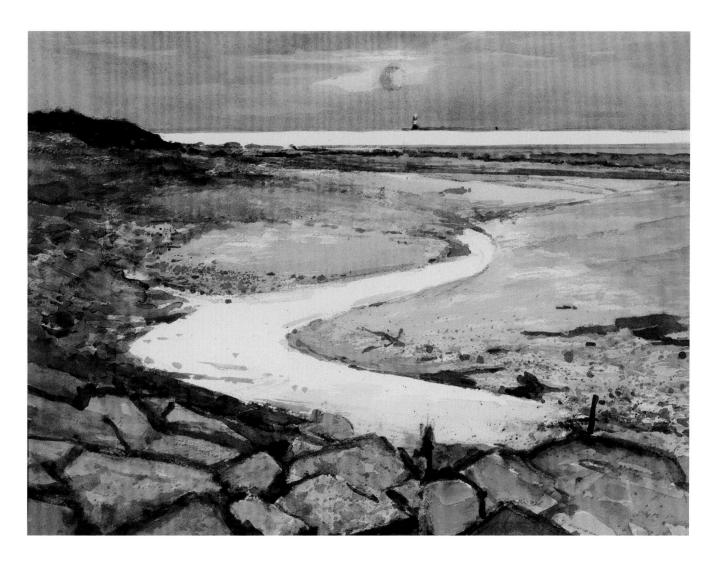

at heart. The quieter places where sea meets sky and land, marshy fens and muddy riverbanks are my source of inspiration. I seek out the abstract quality of my subjects and the drawings I make need to be mulled over before painting starts, always on stretched paper and in my studio. I usually paint fast, using several brushes; it is often rather messy, running over the board, the worktop and sometimes the floor.

Due to family connections I have made frequent visits to west Wales over the years and have become inspired by a particular part of the coast. The foreshore and many of the inlets resonate in a familiar way. I live near an estuary in north-east Essex. The saltings and marshes are nearby and my home and studio overlook a small river valley. Though I have done my fair share of teaching in art colleges and courses for the RWS, my main output has always been my own work. I am very fortunate that my subject is so nearby. One should not try to do it all, do not dilute your energy, rather concentrate on that which is of the greater significance and learn to understand life through your art.

Far left: **Autumn Reeds** 2008 watercolour 44 x 59cm

Left: **Breakwater** 2009 watercolour 34 x 46cm

Above: **The Estuary** 2011 watercolour 37 x 51cm

Richard Bawden

Painting a watercolour is for me a paradoxical situation. I like a broad sweep of wash: spontaneous, direct and fresh. Yet in contrast I respond to the richness of texture and decoration.

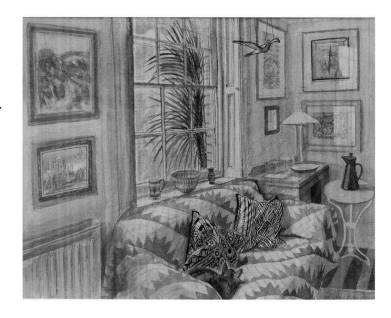

Predominantly, I paint from life; it is a matter of sitting and looking hard at everything, a process that comes naturally, but takes time. Sometimes I will move my stool a yard or two, to bring something else into view.

I am particular in what I see, feel and find as the idea for a painting. When I go out to paint it is often the juxtaposition of man-made shapes, vertical buildings or masts, in contrast to nature; trees in full leaf or crashing waves at the seaside.

I respond to the monumental scale in nature and architecture. Many ideas come from my surroundings. In our house there is an abundance of clutter and chaos: a blazing fire, the cat stretched out, decorative carpets, odd furniture and pictures, flowers from the garden, and my better half a reluctant model. In the garden there is a profusion of plants with contrasting leaves and foliage, also large pots and decorative furniture.

I like the challenge of commissions; there is little choice of subject, and often a location I would not have considered. I was asked to paint Finchingfield, a picturesque tourist village. My idea for the composition was to sit looking across the pond to the road over the bridge up to the church and cottages, all reflected in the water. But there was so much activity of squabbling birds

that I had to re-think my idea. An onlooker said it was a chocolate-box view; I agreed, but the result was not like that. On another occasion I was asked to paint a nondescript Georgian house. I needed a central focus: the tree in the foreground was not enough. The next day I picked up a dead pheasant off the road, propped it on the green under the tree and it made a strong decorative image; just what was required.

Recently I sat in the misty rain on Hungerford Bridge with my sketchbook and paints, during the Royal Jubilee River Pageant. I did some quick, messy lines and squashy effects of boats and rippling water, the royal barge passing directly beneath me and numerous boats, including three with orchestras, a steam boat and Maoris rowing with their tongues out. I also included the Houses of Parliament and the London Eye. From my wet scribbles I worked out a formal design for a large painting.

The paper I prefer at the moment is the RWS rough 300gsm acid-free (which has our watermark). This is a tough paper which can be scrubbed and scraped if need be. I'm impatient and not well organised, so I rarely pre-stretch paper: I fix it down with masking tape, then do the 'work of art', and then take it off the board, dampen the back carefully, lay it between two sheets of blotting paper and drawing boards with a weight on top, change the blotting paper several times and leave overnight.

I start drawing with a 4B pencil, indicating roughly where everything will be in the composition. Then I mix up a mixture of white and umber, or grey-blue paint; this should be the consistency of single cream so that when I feed it onto my dip pen it does not run off and make a splodge. By using a pale tone I draw with a bold line that is not too hard or dominant; I never use black. I prefer paint to ink, because it does not stain the paper or

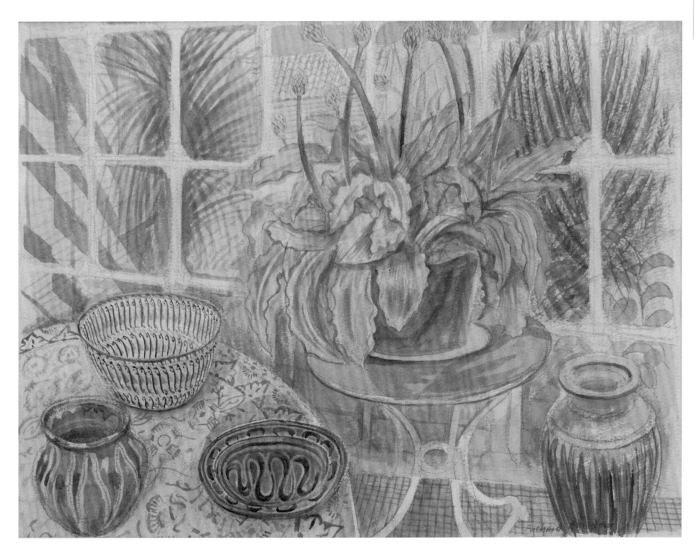

bleed when painted over. A good sable is a joy to paint with and a large brush with a fine point is even better; I use an old brush to mix my colours.

The beauty of watercolour is the fresh transparent colour over the best handmade paper, but I try not to be intimidated by technique. It is often better to make a lively mess than a dead accurate representation, and wet into wet can be lovely.

Left: **Patchwork Sofa** 2010 watercolour 46 x 59cm

Above: **Caroline's Plants** 2011 watercolour 38 x 51cm

Right: **Crag Path, Looking South** 2005 watercolour 52 x 70cm

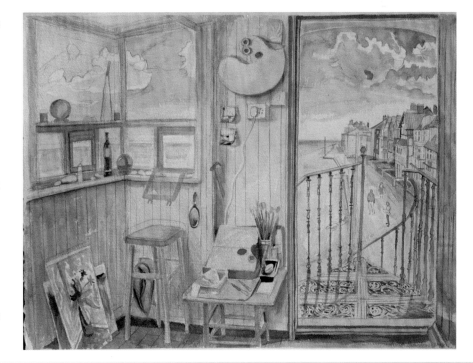

June Berry

My paintings often refer to the seasons or the time of day, perhaps because whatever it is that fires my imagination usually includes people in their environment, so that the mood, light and atmosphere of the moment become an important ingredient of the image in my mind.

I work for a few months of the year in France and find the rural life there just as fascinating as the very different environment of south-east London where I live and paint for the rest of the year.

I never paint on location but simply collect information in my memory, sketchbooks and camera. The photography is mostly disappointing as the camera never seems to see what I see. However, it serves as a reminder of how I felt, which is useful since the

paintings are an attempt to express the delight, surprise, amusement or perhaps nostalgia or sadness that I had experienced.

Back in the studio, after a lot of preliminary drawing and composition planning, work begins directly onto wet paper, unstretched and laid on a sheet of plastic to keep it damp. The image is drawn in with a brush in a very light tone, or some areas of pale colour, using a sponge to correct mistakes, and then built up gradually

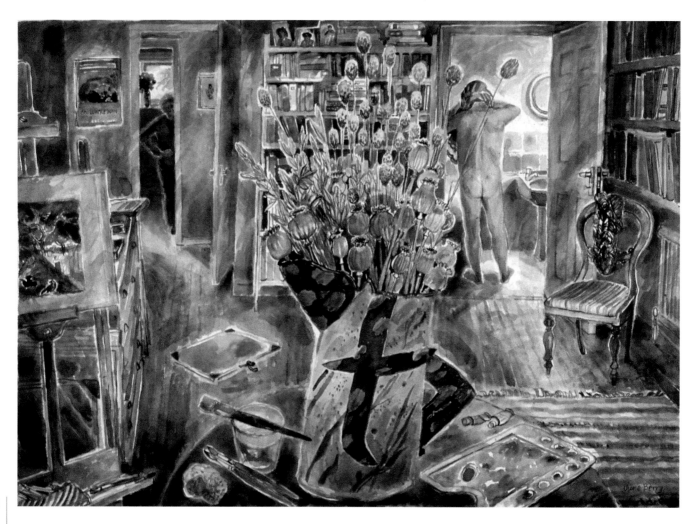

Left: **Bird Jug** 1992 watercolour 51 x 71cm

Below: **Dewy Morning** 2008 watercolour 51 x 66cm

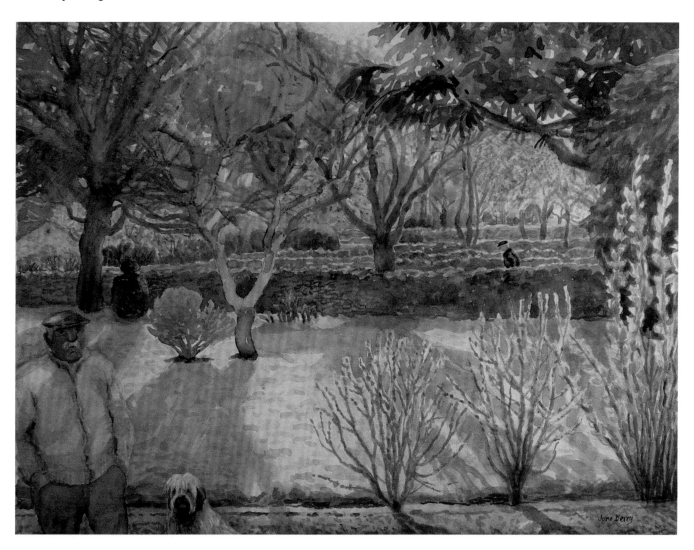

with more layers of colour. A fine spray is useful to keep the paper damp as the painting progresses.

I grew up in the Lincolnshire fens, hating the flat, treeless, inhospitable landscape and the relentless east wind that I had to contend with when cycling to school. Perhaps as a result my compositions are usually constructed closed at both sides by trees or buildings and with a high horizon line and little sky. Wide open vistas are not

for me! I like to find rhyming shapes that can appear across the composition and create an underlying rhythm – a bit like a fugue. My palette is restricted to a few colours, mostly made from the same ingredients, which help to suggest the mood of the subject, as in *Late in the Day*. Some compositions are split into a diptych or triptych as in *The House, Spring*.

As a late developer, or slow burner as it is sometimes described, having

taken time out to raise a family, as many women artists do, I am happy that each new painting is still a leap into the unknown, and it gives me great pleasure when the image seems, in the end, to bear some resemblance to my ambition for it.

Akash Bhatt

I have been very fortunate that my work has given me the opportunity to travel widely. However, I am equally comfortable working from material closer to home, something that is necessary as it keeps the whole machine of creativity well-oiled and balanced for me.

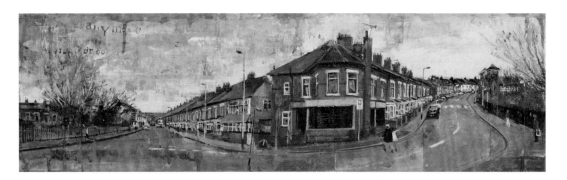

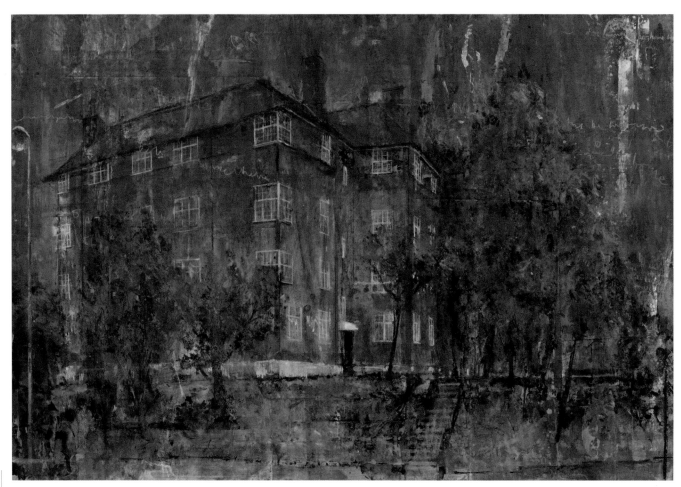

Left, top: **I Wasn't There Anymore** 2012 watercolour 23 x 76cm

Left, below: **Stop Looking at Me** 2011 watercolour 66 x 96cm

Below: **Follower** 2012 watercolour and ink 57x 77cm

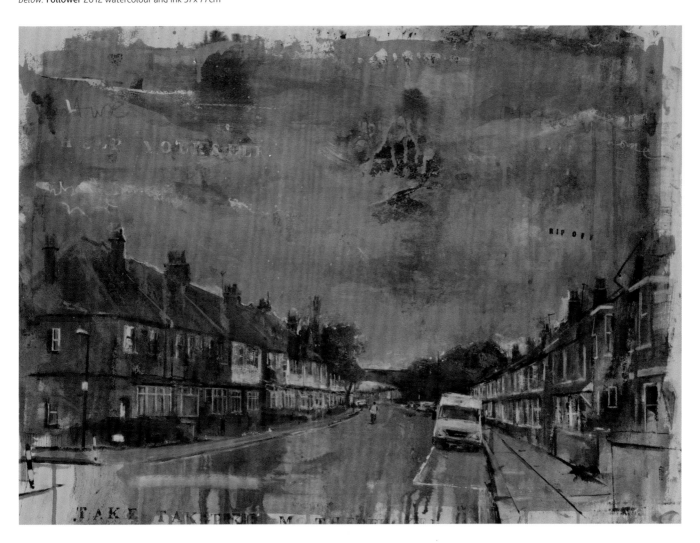

Sketchbooks are the most important aspect of my working process. They are an invaluable source of information accumulated over many years and give me the freedom to dip into them whenever I choose. My paintings are a combination of these observations interwoven with my own personal narrative. I often use watercolour directly from the tube without much water, hence the opaque quality of some of my work. I paint directly so there is no drawing mapped out underneath for any of my work.

Life as an artist is very often a solitary existence that is seldom rewarded by those rare, fleeting glimpses of ecstasy that come with a successful period of work. Being stuck in a studio for long stretches is not always conducive to creativity, and painting can often become a form of self-flagellation.

The process of working for me is a constant pulling and pushing of ideas where mistakes, disappointments and failures are all worthwhile when things fall into place and this never-ending

chase reaches a temporary conclusion. It is a temporary conclusion because the next painting is waiting in the background, taunting me with its own challenges and obstacles bringing a new set of problems for me to solve.

My approach to the process changes all the time. To some extent my own fear of becoming complacent drives me to find new ways of working to create work that not only challenges but keeps me interested and also gives me the energy to return to the studio every day.

Dennis Roxby Bott

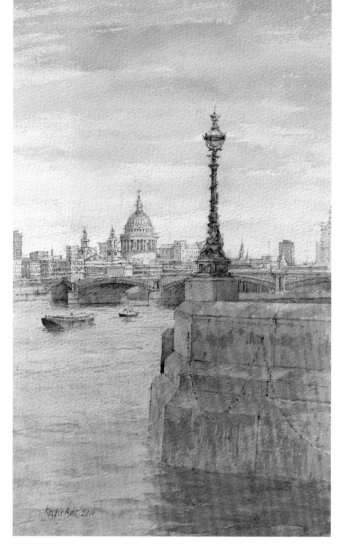

When I was a student in Norwich, I regularly visited the Castle Museum, where they have a great collection by the Norwich School painters. I think that these reinforced my preference for topographical painting. Landscape has always been my main inspiration, but specifically architecture within the landscape rather than pure empty countryside. In fact, I find that I am interested in depicting many man-made objects in the environment: cars, carts, boats, barns or any buildings and artefacts in the landscape. Dilapidation has a great appeal to me. Once a thing has been rigorously restored it loses its romance.

My work always begins sitting or standing with an easel in front of the scene, and doing a detailed line drawing on paper already stretched on a board. At this stage I apply washes to the picture to include the main colours and the shadows, and the sky, which gives a key to the whole pairing and captures the immediacy of the atmosphere. If the weather is not suitable, though, these may have to be done on a second visit. I like to take detailed notes after I stop painting while I am still at the site, which I use as an *aide-mémoire* when I finish the work in my studio, though the more I can complete at the scene the better.

I like to use a rough paper as I feel it has a kind of sympathy with the buildings and the surrounding landscape or townscape, which gives a lead into the painting. It feels as if the picture is already there and waiting to emerge.

I always take particular note of what the shape and patterns of shadows in the composition will be. These are, of course, just as important as the outlines, as they give shape, form and dimension to the composition. This means that sunshine is necessary for me to proceed with the work, leading often to great frustration trying to paint in this country. The only time I got a speeding fine was when I had driven 80 miles to Oxford to paint a commission with a deadline, only to see the clouds getting thicker and thicker, an event which had not been predicted by the weather forecast.

If planning a painting when the weather is cloudy, I take a compass with me, so that I can see where the sun will be when it does come out. This enables me to work out when I need to be back at the site to catch the best light.

This naturally makes painting trips to Venice, Malta, the south of France etc. much more advantageous. Apart from the stunning scenes and more

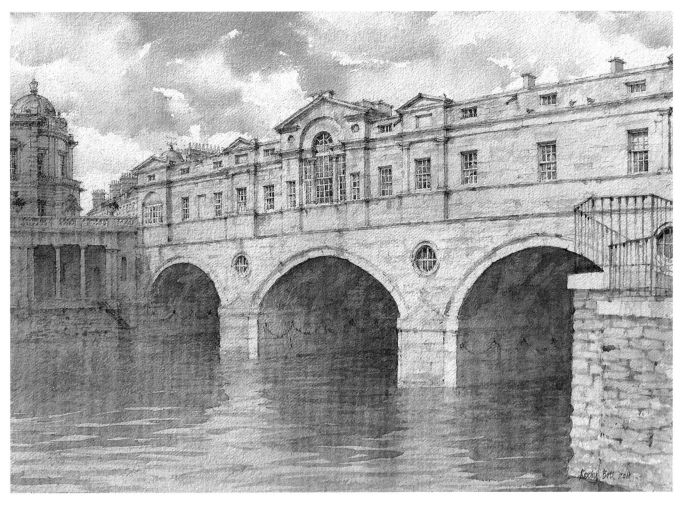

Above: **Pulteney Bridge, Bath** 2011 watercolour
71 x 51cm

Left: **Saint Paul's from the South Bank, London**
watercolour 2010 46 x 31cm

Below: **Santa Maria della Salute, Venice** 2010
watercolour 46 x 31cm

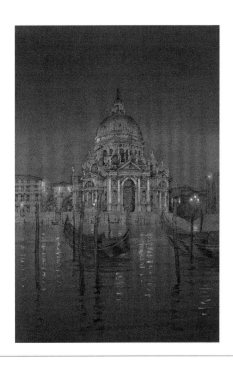

vivid colours, compared to our more muted light here in Britain, there is usually sunshine. Venice also has the great advantage of having more places to sit or stand and draw without having to avoid busy roads, parked cars, lorries and ugly street furniture.

I nearly always work from the start on the actual painting rather than using studies or photographs. On the rare occasions when this has not been practical I miss the spontaneity and excitement that come from the atmosphere of the subject before me.

I prefer drawing and painting sitting down, as I believe many watercolourists do. It gives you more control over the flow of paint, but the composition often demands a different perspective and is more effective from a standing position. It often helps to see over parked cars and other obstacles too.

A danger of topographical work is that the picture produced could end up with the atmosphere of a snapshot. It is for this reason that I rarely include figures. One then also has the danger of the view looking like a deserted stage set. For this reason I always hope that my work will have the warmth and spirit of the actual place, which attracted me to paint it in the first place.

Francis Bowyer

Locations for paintings include my studio and atmospheric interiors such as restaurants; also the coast, Walberswick, Suffolk. Familiarity with the subjects that I paint is very important to me.

The more understanding I have of a particular place, the better I am at expressing my feelings for it. I find that this strengthens my vision as the work progresses.

That doesn't mean that I don't engage with new themes. I am always looking to explore new possibilities. It's about researching a theme over a period of time that I can visually digest and ultimately connect with, so that I can understand and be inspired by elements that intrinsically make up the subject. Light and atmosphere are key for my work at present.

Good fortune plays an important part in my work, as in *Snow Storm, Chiswick Mall*. I was painting on the spot, in the freezing cold down by the Thames in Chiswick, London. The picture was full of detail and I noticed that the watercolour paint had become inexplicably lumpy. After a couple of hours I decided to seek the warmth of my studio, where I realised that the paint had frozen while I was out by the river and the fine detail (into which I had put so much effort) had now melted. My picture had become full of the snowy atmosphere of that day, and I had inadvertently learnt a valuable lesson in adapting to circumstances that are not entirely in your control and allowing the intuitive side of your nature to develop.

Morning Sunlight in the Studio came from a series of pictures that I just had to paint. My studio has a window on the slope of the roof and sunlight illuminates and creates unusual shapes on my sink, across the studio floor and wall throughout the day. Here is one of a series of quiet contemplative paintings which I hope the viewer can engage with me on. I found that the images almost had a church-like quality to them conveying, I hope, a peaceful serenity.

An important part of my childhood and adult life has been regular visits to Walberswick in Suffolk, which I know so well. *Old Walberswick Pier* depicts where now only the wooden skeleton remains, rising up out of the sand and creating wonderful enigmatic shapes. I painted it under a dramatic and typical East Anglian sky.

Over a number of years I have made paintings of Parisian restaurants, like Chartier and Le Grand Colbert. As soon as I first visited I was utterly seduced by the

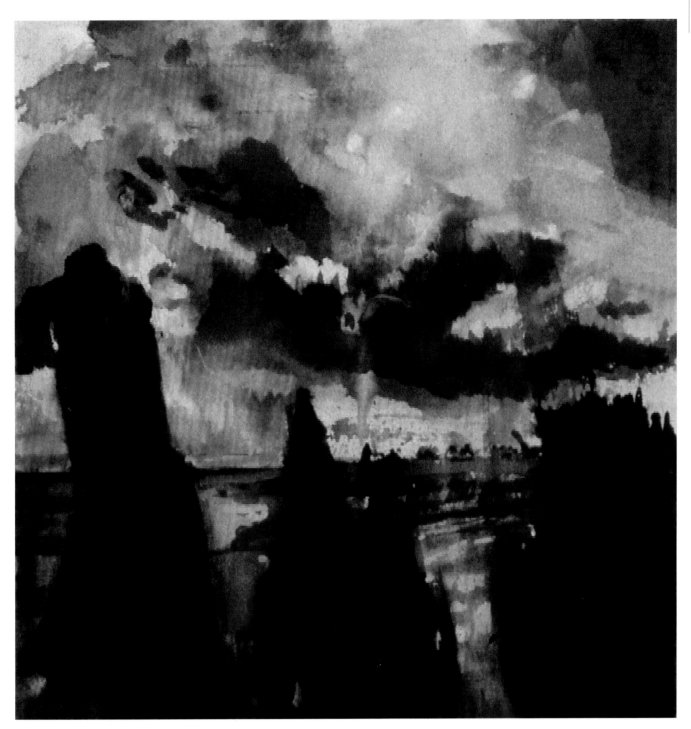

lavish interiors and lively atmosphere within these restaurants with their busy waiters. From these series I was commissioned to produce *The Ivy Restaurant, Covent Garden.* I often go to restaurants in the early evening, when it tends to be quieter and there are fewer distractions, so I can draw and collect reference.

Using watercolour and water-based paints is of course thrilling – holding the brush, applying the paint – but it is just part of the process. Finding that other element, that spark of visual excitement, that memory of a place, has to be the first port of call on a wonderful journey.

Far left: **Snow Storm, Chiswick Mall** 2012 watercolour 30 x 35cm

Left: **Morning Sunlight in the Studio** 2012 watercolour 80 x 120cm

Above: **Old Walberswick Pier** 2012 watercolour 30 x 30cm

William Bowyer

If I am on one of my painting jaunts, it is because I have seen an image that has stimulated my imagination: something intriguing, exciting and challenging. It might be the juxtaposition of objects against contrasting backgrounds or a composition of sensual colour and tones – whatever has impressed my visual senses.

In my young days, in the undulating moorlands of North Staffordshire, I would paint only *en plein air*. Come winter, summer, I loved interpreting the open landscape and its changing seasons. Winter with snow was particularly revealing with its stark abstract quality. This could mean the water freezing on my paper; contributing to some surprise brushstrokes and washes as the painting slowly dried. Summer and hot days could not have been more different. Constantly sponging my painting to try and hold my big washes fluid, and the battle to keep the gum strip forming by having a tug of war with the paper meant that it was an achievement if I felt the least bit happy at the end of the day.

Getting all my paraphernalia together is a chore if I am going some distance to set up for several hours. Easel, prepared boards, paints, brushes, sponges, water and large palettes. This is especially difficult when travelling abroad. Boards being too heavy and cumbersome to take, I haunt local wood yards and with a little bargaining and comical sign language (not too difficult for a visual artist!) I manage to pick up a 24"x24" and an 18"x18" board.

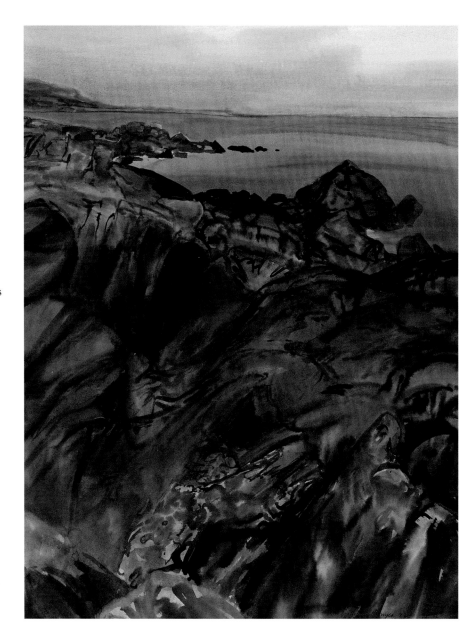

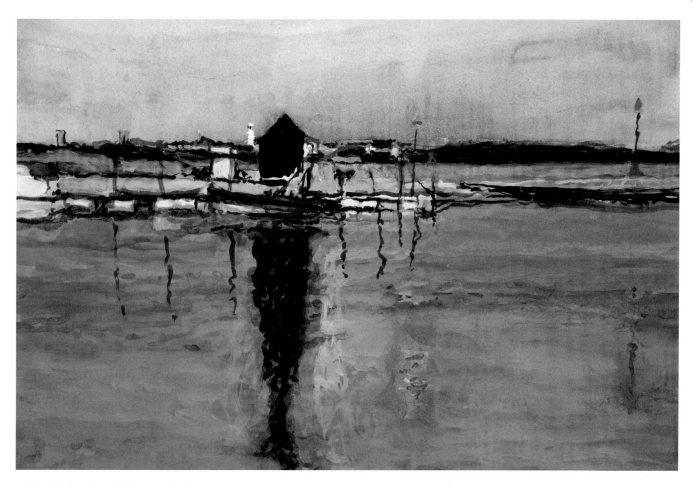

Left: **Cornish Rock Forms** 1975 watercolour & bodycolour 62 x 64cm

Above: **Red Speedboat** 2013 watercolour & bodycolour 50cm x 70cm

It is not surprising that having painted in so many different parts of the world from the Far East to South America, the Middle East to Africa and New Zealand, I am still attracted to our own east coast of England. Familiarity means I know it intimately in all its moods and seasons and that there is still a vast amount of enticing work to be done.

I have always favoured a toned, smooth, heavyweight paper and the best quality paints I can afford. My favoured watercolour palette contains Cadmium Red and Cadmium Yellow, Cobalt, Ultramarine, Ceruleum and Manganese Blue, which are a few of the basic colours, together with Titanium White (gouache) and Ivory Black watercolour.

I have always enjoyed painting people and being in their company. There is a challenge to capture that elusive human quality that reveals their unique nature.

I started painting 68 years ago and it has been a discovery of myself and the visual world and has resulted in an abiding love. Since I was elected to the RWS in 1958, I have enjoyed the company and the work of so many Members over the years. It has been a privilege to belong to the Society and ... NOW BACK TO WORK!

David Brayne

I find making the first marks so difficult, for me it must be the most exacting stage of any painting. I paint from memory and the initial marks are often scrappy as I try to clarify my ideas.

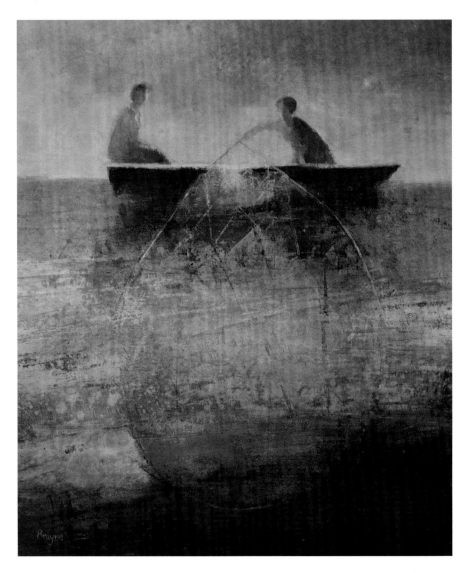

I begin by drawing with pencils and there's usually a lot of rubbing out, so the surface of the paper soon becomes scruffy as well as scrappy; covered in a faint tangle of lines and smudges that sometimes offer unexpected ideas. At this stage there is a pressing need to concentrate and become fully absorbed in order to make sense of it all. The painting has now truly started and decisions about what to do next are determined by what's on the paper. Now I enter into the act of balancing what's on the paper with what I can actually achieve. The drawing becomes the painting, there are no sketches or preparatory drawings – it's all worked out on the surface of what will become the completed picture.

If the painting is not right, then I simply fix the surface with an acrylic medium and, if the problem is not too serious, continue to work over the troublesome area with pastels, graphite or watercolour. When all else fails I use an opaque mix containing a fair amount of Titanium White.

I paint as simply as I can. An important element in this approach is my choice of paint. I make my own. This is not as difficult as it first may seem; after all paint is merely a mixture of pigment (a coloured substance) and a binder (the ingredient that fixes the pigment to the support, whether it's canvas, a plaster wall or paper). Specialist manufacturers produce and prepare pigments, which are finely ground and nearly always ready to use. I invariably combine these with an acrylic medium, though occasionally, when I wish to apply a number of transparent glazes, I try a commercially produced, ready-refined gum arabic mixture. I sometimes combine the ingredients directly on the painting's surface. This allows me the opportunity to change or adjust the ratio of pigment to medium as I work and to achieve the desired degree of transparency. I find that by working in this way I have more choice and control. The range of colours available as raw pigments is amazing; some might be very insipid and have the colour of dust from a vacuum cleaner, but pigments are never boring and I can usually find a use for the range of 100 or so I have in my studio. Several pigments, which perhaps look dull

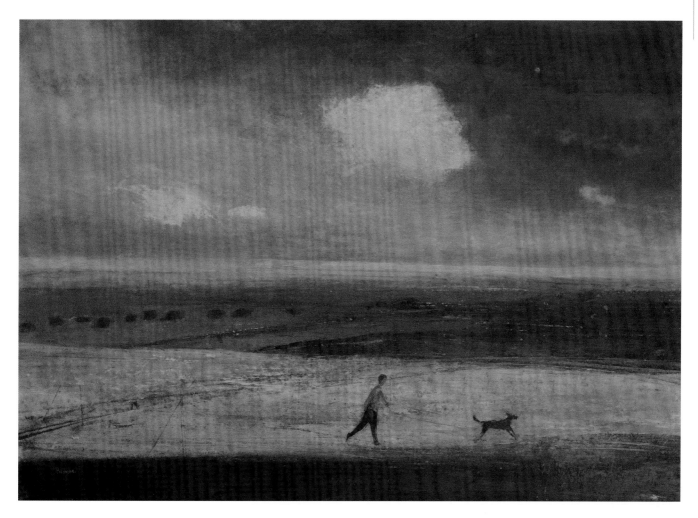

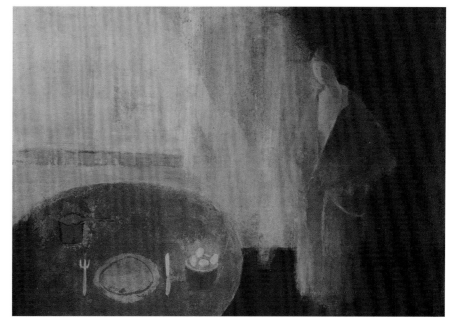

and uninteresting and/or have little staining power, can come into their own when I want to apply a glaze or need to make a slight change to the tone of a too dominant blue or orange. One of the great joys of using raw pigments is that they so often surprise; I would become bored very quickly if painting were predictable.

I work with very wet paint, so always stretch my paper and lay the stretcher board on a flat surface, either the big plan chest in my studio, or else on trestle tables near the heater (this speeds up the drying process; in the summer I put them outside in the sun). The paper needs to be robust. I sometimes wipe, scrub and scratch the surface with rags and sticks as well as brushes. I have been known to make holes, but they can always be patched up.

Left: **Fisherwomen** 2012 pigments & watercolour 56 x 50cm

Top: **The River and the Sea** 2012 pigments & watercolour 65 x 90cm

Above: **Breakfast with William Scott** 2012 pigments & watercolour 34 x 47cm

Liz Butler

The first time I remember working on a small scale was as a student in the life-drawing room at Liverpool College of Art. I was very unsure about my work and rather tentative in my approach.

What I hadn't realised at that time was that I had already been seeing things very differently from other people. My youth was spent in the Cumbrian countryside and I was fascinated by the intricacy of nature. Subtle variations in the design of plants, each with their own identity and yet with family similarities, made me scrutinise them closely. I became interested in microenvironments, especially damp places inhabited by mosses, liverworts, lichens and tiny ferns. As a child, using my imagination, I set many stories and poems I had read within those tiny landscapes. On rainy or wintry days I was allowed to leaf through an enormous book of detailed black and white photographs of worldwide scenes. Earthquakes and other natural phenomena featured strongly. They fascinated me because of their pin-point sharpness.

It was not until I had left the countryside and was in my last year at the Royal College of Art that I used watercolour. Previously I had been using a variety of materials to express myself, including pen and ink, and producing some obsessive little drawings of strange worlds, set within the real environment. They were intensely worked, often growing out from some point in the middle, so that the outer edge of the drawing was revealed at the very end. Often I had to add on extra bits to reach a satisfactory composition, and they sometimes ended up being distorted rectangles, rather like embroideries when the tension pulls them in one direction. Living in the city, I began to miss the countryside and picked up some watercolours to try. I was amazed at just how wonderful they were, the richness of colour that could be achieved, and the subtlety, the marvellous transparency of some colours and the translucency of others. You can draw with them using the right brushes and then let them run away with themselves and allow them to do their own thing.

I began to use them initially to paint botanical studies, later moving on to paint gardens and small landscapes. These early landscapes were miniature in scale and I could develop incredible depth of colour and intensity, especially using the transparent pigments from the watercolour range. Working small, I began to invite my audience to come close, peer in and step inside my paintings and inhabit the space.

Left: **Autumn in the Park** 2011 watercolour 12.25 x
8.25cm

Below: **Umbrian Landscape, Late Summer** 2012
watercolour 13 x 18.5cm

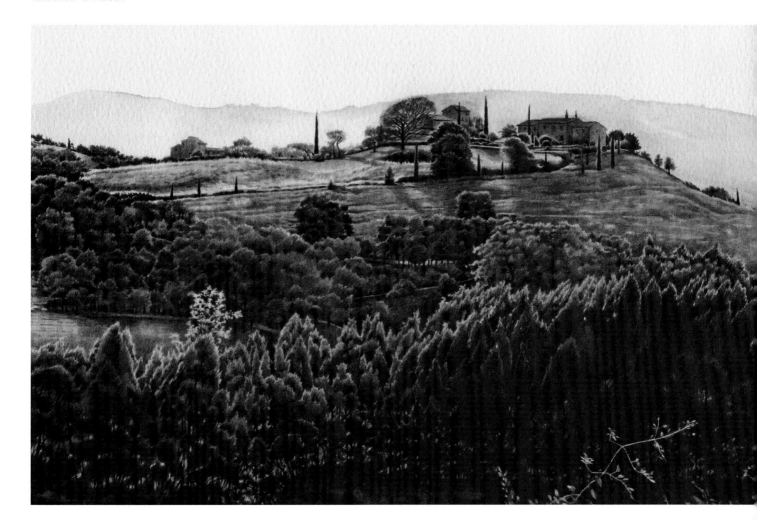

The rich, dark colours are achieved by laying down dozens of washes. Sometimes I lay down the washes as flat colour, other times I stipple layer over layer. As far as the subject matter is concerned, I am merely sharing an experience, which is not necessarily all it appears. Initially one of my paintings can look just like a view, but looking more closely, they possess an element of mystery. In fact I find that the precision of the work helps to create a sense of mystery, a quality that I greatly admire in the work of Vermeer. Technically, I aim not to show any brush marks in my work, I want my paintings to appear on the page magically, as if they haven't been made by human hand. I like the haunting mystery in gardens and at ancient sites. They have absorbed something from those who made them and the many generations passing through, who haunt them still.

I am painting larger paintings now and am working along similar themes and maintaining similar working methods, still hoping to provoke thought and enquiry, while giving my audience the opportunity to find more on further inspection. Lately I have enjoyed using the paint in an out-of-focus way, contrasting it with more controlled and drawn areas. These are mainly paintings of landscapes from the air, looking at patterns on the surface of the earth; I am particularly interested in the patterns formed by alluvium deposited in river estuaries and how land has been changed by man's use of it.

Michael Chaplin

It feels to me, looking back on a lifetime of painting, that there is still an awful lot to learn, still a huge amount of world out there and still a mountain of paint crying out to be moved from A to B. The Latin tag 'vagor, miror et adoro' (I wander, marvel and adore) is a text that goes right to the core of what most of us expect in our privileged chosen route through life, time to stare, a facility to create and an urge to move on to new experiences.

For me this happens first in the sketchbook. I think I'm at my happiest when putting down fast, simple notes either in line or colour. I am not a 'natural' with colour. I need a simple cunning plan often revolving round the counterpoint between warm and cool areas, with any drama coming from strong tonal variations. I mention drama because I am at heart a narrative painter. I like the story of quiet empty spaces, interiors and exteriors with only a minimal mention of human activity, for instance *Water Carriers on the Nile* (which won the Turner Watercolour Award), or the calm monumental grandeur of a cathedral.

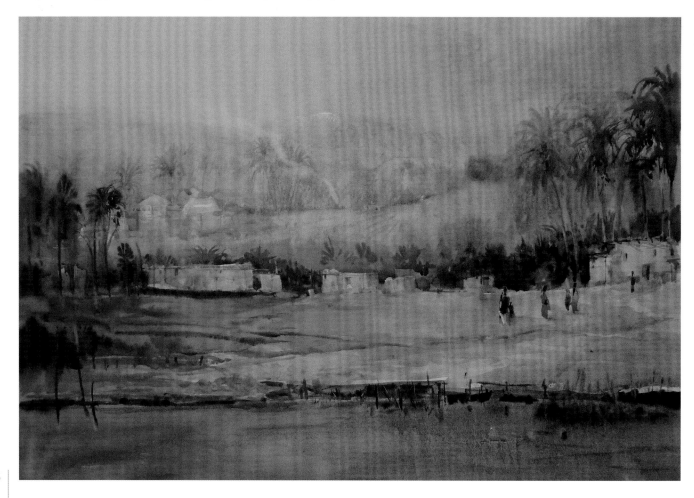

Left: **Water Carriers on the Nile** 2011 watercolour
45 x 65cm

Right: **Venice Colour Study (Academia Bridge)** 2010
watercolour 20 x 30cm

Below: **St John's Co-Cathedral, Valetta** 2012
watercolour 45 x 65cm

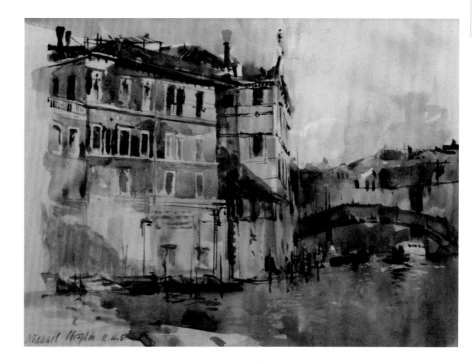

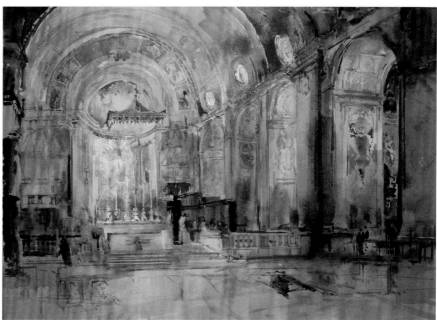

These larger watercolours are painted in the studio, working direct from the sketchbook with no preliminary drawing on the paper. Many years as an etcher (I was vice-president of the RE) taught me to have a fairly acute eye when seeing where things should be on the paper, so it's straight in with the big washes. I like to work fast. The first two minutes of a watercolour are always exciting for me and I prefer to finish a painting in one sitting. It is rare for me to work for more than three hours on a large watercolour. If it hasn't 'happened' for me by then, then I am more than likely to start again. I try not to fiddle but often do. It's a signal that I ought to put the brush down, which I'm sometimes wise enough to heed. I'm lucky to have a (small) stock of pre-1950 Whatman handmade paper, very thin and gelatine-sized. It still has its original 'crackle' when shaken. The paint floats beautifully on the surface so there is plenty of time to lift off and manipulate colour. What joy!

I've been fortunate to work with Tate Britain on several J.M.W. Turner projects. Films showing his working techniques (using Turner's pigments left in his studio!) and books on the same subject (*How to Paint Like Turner* – Tate Publications) have been a fascinating research into eighteenth- and nineteenth-century techniques and have taught me much both technically and aesthetically. Filming on the *Watercolour Challenge* Channel 4 programmes in the late 1990s (over 60 programmes) I saw as an extension to the teaching that I have always enjoyed. Recreating Turner's magnificent oil *Ship Caught in a Snow Storm Off Harwich Harbour* for Japanese National Television in 2012 brought its own challenges, but again taught me much about attitude, (nothing ventured....etc.).

I consider that I have been extraordinarily lucky to have had the opportunity to spend my life as a painter.

Helga Chart

Watercolour is one of the most challenging and yet inspiring of the media that I use. I was introduced to the potential of the medium by my art school tutor Sir William Gillies who, incidentally, recommended his students never to clean their palettes!

Much later in my painting life I discovered the excitement of working with watercolour on a variety of paper surfaces. I like the unexpected bleed that occurs on unsized papers, or the interesting results to be had with collage and print in combination with watercolour.

Much of my inspiration comes from natural history. My subject matter is often based on landscape, natural form and the weather of seasons. The lives of the great naturalists, the manner of their research, their methods, tools and instruments are as of much interest to me as the subjects of their studies. I travel within Scotland – the Western Isles being a particularly fruitful spot. I also visit natural history collections, both at home and abroad. Studies in these collections provide me with valuable information for development into final pieces.

I fill my sketchbooks with as much material, both written and graphic, as I can lay my hands on. Where possible I draw from primary sources, but also write up any related material which I consider of value from reference books. Thus my sketchbooks contain an eclectic mix of colour notes, texture details and compositional ideas.

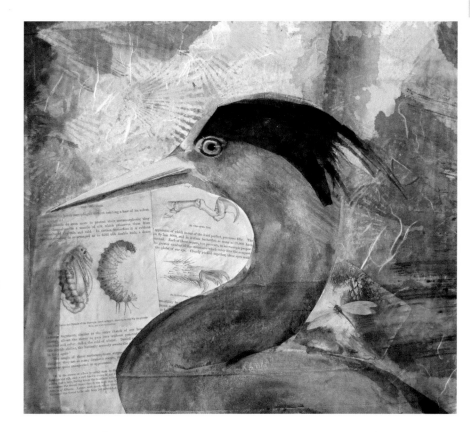

My method of work, whether it be straight watercolour or mixed media with collage and print, is usually determined by the subject matter. Sometimes texture in the paint is obtained from salt grains.

On other occasions abrupt changes of colour or tone require the use of collage or stencils. In my paintings I use sponges and squirrel-hair brushes and often employ Japanese brushes for their flow and the resulting unique marks.

If I do have an occasional painting 'block', I work through it with a day of mark-making or experimental printing. The resulting papers have no particular use at that time, but do provide me with a bank of material to use in my work at some future date.

Left: **Masterbuilder** 2008 watercolour, ink & gouache 65 x 114cm

Above: **Heron** 2011 watercolour & collage 40 x 40cm

Right: **'P' is for Poison** 2008 gouache 40 x 60cm

Michael Collins

I begin a painting usually when I have what I consider to be enough visual research in the form of drawings, done in front of the subject. I make colour notes on the drawings and I take some photographs as possible reference. I think my better paintings are the ones I've carried around in my head for a while.

I'm interested in trying to get both flatness and depth in my work. I think this is something that preoccupied many 20th-century painters. I like to trace this back to the early Italian primitive painters of the 13th, 14th and 15th centuries, who showed strength in design and composition. They looked to fit objects into shapes and used pattern to add to the overall rhythm of the work, as well as making wonderful use of colour and tone

Left: **Boot Camp at the Seaside** 2012 watercolour
50 x 65cm

Right: **Birling Gap** 2012 acrylic 45 x 64cm

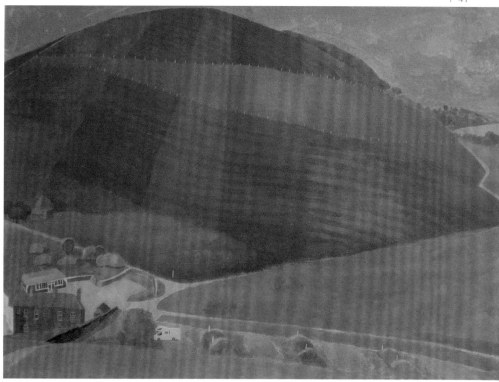

which gives unity to their work. Often, the result is a surprising mixture of depth and flatness, vagueness and clarity. Their work has other qualities which I can only describe as a 'static stillness', giving emphasis to a detached, aloof atmosphere – something I'm interested in exploring with my own work. I think John Sell Cotman also has many of the aforementioned qualities: I don't think I've ever seen a Cotman that wasn't good.

A few years ago, my paintings leant more towards a particular narrative. In more recent times they do so less. As mentioned above, when I'm in front of a subject, formal qualities take precedence: i.e. getting information down on paper that will allow me to progress with ideas for a painting. If I've observed features of a landscape, I can manipulate these things into my work. A number of my paintings have what I call 'incidents' in them, such as *Boot Camp at the Seaside*. The idea came from observing groups of people exercising every morning and evening on the hill across from a hotel where I was staying.

All my work is drawing-based; I'm not what I'd call a painterly painter. At one time I would draw everything first and fill it in with paint bit by bit. I work in small areas, keeping an eye on the whole painting's progression. These days I generally draw the main components and then go in with the paint. Sometimes, with watercolours especially, there's little or no drawing and straight in with the washes.

I have begun to vary the application of paint, particularly acrylics, applying layers of thin wash along with flat areas of more opaque paint. With acrylics I use a combination of a matt and gloss medium, which produces a satin finish when mixed with the paint. Just using water with acrylics, I find that the colours can lose their life and look a bit dirty and dead.

With watercolours I use Winsor & Newton artist-quality paints. Recently I invested in a Da Vinci Artissimo 44 sable brush, which is the finest brush I've used for watercolour. It has a wonderful point and holds a decent amount of colour. I also use a soft, square brush for large areas and a rigger for lines or detail. A dip pen loaded with watercolour is also good for this. I use smooth Arches paper, which suits my way of working. I also use Bristol board; with this the watercolour tends to sit on the surface and gives good clarity to the washes.

I also like the heavier rag paper: the paint sinks in as I imagine paint would into plaster in fresco painting.

In the last couple of years I have been experimenting with acrylic gouache. The colours are good quality and dry to a matt eggshell finish. They can be used thinly like watercolours or with a thicker consistency. They are like acrylics in that a dry wash can be worked over without lifting off as in traditional gouache.

Painters who interest me most are those who play with scale and space in combination with depicting observed objects, using their strong underlying abstract nature to inform paintings. Besides Cotman, such artists include Edouard Vuillard, Pierre Bonnard, Keith Vaughan, Stanley Spencer, Edward Bawden, Eric Ravilious, John Nash and Ben Shahn. In more recent times, Leonard Rosoman, Jane Dowling and Leonard McComb are painters whose work I look out for.

Jane Corsellis

If I am lucky, I will see a scene and immediately know that I want to paint it, but more often it is a case of looking around me and eventually something will arrest my attention. I am interested in the unusual, *such as patterns of unexpected light on objects, people or landscapes, warm colours against cool ones, light against dark, strong versus pale. All these contrasts go towards choosing a subject.*

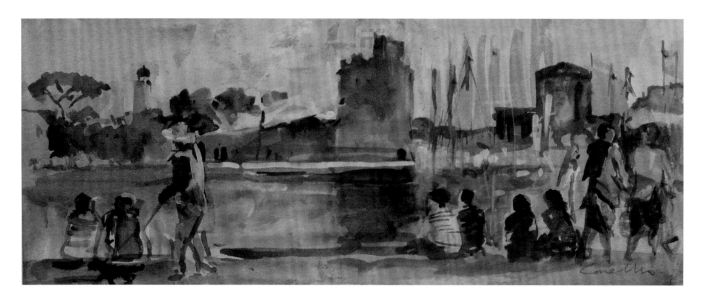

I keep a small sketchbook, more of a pocket notebook, with me at all times. This is invaluable as I can make written notes, scribbles or detailed sketches of anything that interests me and decide on the subject back in the studio. Another useful aid is to carry a small field box of watercolours and to make as many quick colour studies as possible. I have hundreds of these sketches and they are just painted for information rather than for any artistic merit. They are a great starting point for a painting; looking at them I can recapture the initial excitement of the moment. Somehow a photograph never gives the same feeling. However, I do use a camera as well, as it records points that I have missed.

Having selected a subject, I make a number of drawings in order to work up a compositional structure and rough tonal layout before finally deciding on the size and the paper to use. This depends on which type of paper I think is sympathetic to the subject.

Choosing a paper is a difficult but interesting problem. Which to use? A rough or a smooth surface? I tend to prefer a tinted paper like the classic Turner Grey, a beautiful semi-smooth surface with just enough grit in the paper to hold the paint in a pleasing way. Lately I have used another paper, a rich subtle green-brown also favoured by Turner. I do not need to wet these papers to

stretch them, but just tape them on all sides with masking tape to a firm board. Both are strong enough to take a wet wash without buckling. I usually use the German Schmincke range of watercolours. I squeeze the pigment straight onto the palette or into the pans in the paintbox.

Then it's down to work! The exciting part is always the start of a painting. I like to work with loose washes laid on with an assortment of brushes, from house painter's bristle to fine sable, sponge, rag, fingers or anything to get the effect I want. I try not to get waylaid by rigid rules of technique but just get on with it and learn from mistakes and glory in unexpected discoveries. This does

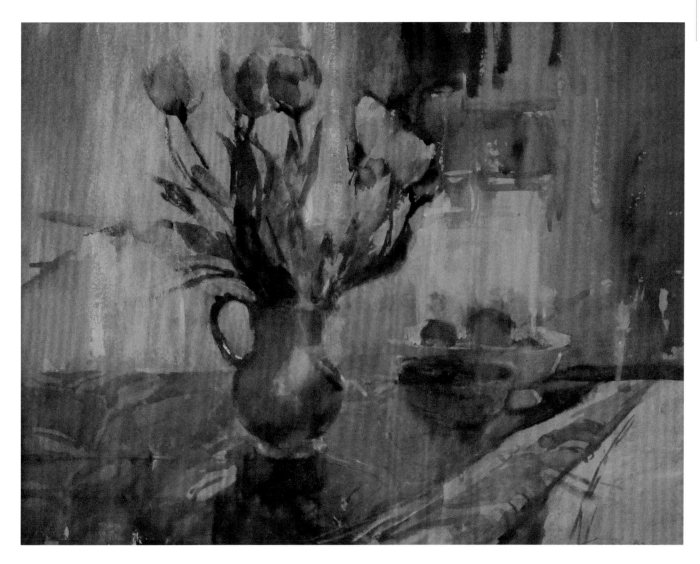

require a certain amount of bravery and one must not despair if it all goes wrong. After all, I can always sponge it off in a bath of water and then there is an interesting base for a new painting! It is so difficult to know when a painting is finished, but my guide is to decide that I have no more to say about the subject and to leave it alone ... for the moment!

Left: **Morning Strollers, Honfleur, France** 2012 watercolour 10 x 25cm

Top: **Tulips by the Window** 2012 watercolour 40 x 50cm

Above: Jane Corsellis, **The Road to Montegabbione, Umbria** 2012 watercolour 18 x 28cm

Clare Dalby

What inspires me? Sometimes it's the light; sometimes it's the rhythm of buildings; sometimes it's just a favourite place. Landscapes are in many ways the total opposite of still lifes; in these I select and carefully place each of the ingredients in relation to my chosen viewpoint, while ensuring that the light falls from just the right angle. By contrast a landscape waits to be discovered and explored, and only comes to life in particular weather conditions, at a specific time of day.

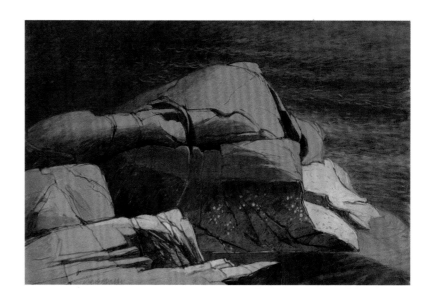

As my work is fairly topographically accurate I spend some time selecting the best spot for making my initial study. Typically this study involves a couple of hours of concentrated drawing with a brush or pencil, and trying to record the essence of what originally attracted me, as well as sufficient detail. The viewpoint tends to be quite low, as it is convenient just to sit on an inflatable cushion with my paintbox (a treasured one, made for my mother by my father, Charles Longbotham RWS) on the ground beside me.

I have been visiting Shetland for many years and love its uncluttered treelessness, huge skies and varied coastline. The weather is spectacularly and famously changeable, which is both its attraction and its challenge. You can start work in a gentle fog of receding silhouettes and soon the sun will break through, replacing subtlety with harsh contrasts. Or an island in a bright sparkling sea will be obliterated by rain clouds suddenly assembling out of nowhere. In addition, there is nearly always a very bracing wind. These outdoor studies – overworked in places while incomplete and scruffy in others – capture a special feeling of place and time in a way that a camera cannot do.

Back in the studio and after some modifications, the final drawing is traced on to my watercolour paper, using a light box. As the paper needs to be thin to transmit light, it then has to be stretched. The method of painting after that depends on the subject, and may involve starting with the sky, or applying an all-over wash. Sometimes a particular feature is picked out first, and everything else has to relate to that. Mostly I then build up areas with a small brush, and consequently favour hot-pressed paper.

The inspiration for *Vaila Afternoon* was the light reflecting from the slate roofs, with the added bonus of being able to see the remote, magical island of Foula behind the watchtower – while the mist in Scalloway enabled the colours of the boats to predominate, rather than contrasts of light and shade.

Rarely, a field drawing becomes the framed watercolour. *Incoming Tide* is a portrait of my favourite Shetland rock, glaciated, seaworn and embellished with limpets. I perched on another rock and painted it *in situ*, on stretched tinted Ingres paper, over a series of afternoons.

Stanley Mills are half a mile from home. On this occasion, there were no outdoor studies. Apart from the obvious cold, my chosen viewpoint was from the middle of a large, prickly bush, so I relied on taking and interpreting a number of photographs. As the reddish sandstone of the buildings suffused the entire scene, I decided to cover the whole paper with a burnt sienna wash before working in watercolour reinforced with white gouache.

Left: **Incoming Tide** 2009 watercolour & gouache 29.5 x 20cm

Right: **Stanley Mills** 2009 watercolour & gouache 30 x 21cm

Below: **Vaila Afternoon** 2011 watercolour 30.5 x 19.5cm

Alfred Daniels

*Born in London in 1924, I left grammar school at 14
because of family financial problems. I was advised by
my Uncle Charles, a successful commercial artist, to learn
lettering at the Lawrence David Studio in Chancery Lane.
Working in a studio was a unique experience; the bright
light, the sense of order and industry, the smell of cow gum
glue, the use of soft brushes on Bristol board and fashion
card, black and coloured inks, watercolour and process
white, poster colour and T-squares on the drawing boards.*

Left: **Hammersmith Bridge** 2012 acrylic 62 x 76cm

Right: **The Royal Hotel** 2005 acrylic 41 x 51cm

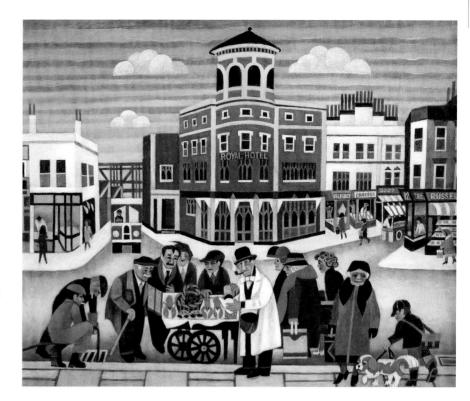

Uncle Charles opened his own studio in Fetter Lane and I was promoted to be his assistant. I did lettering, layouts, paste-ups, and various illustrations when needed, all for a pound a week. My career in art can be summed up by what I learnt and experienced working there. Namely, I was told what to do, but not how to do it. I learnt to have an aim, goal or objective, to work to time, and to deliver finished work to the client.

For my art-school training I was given a grant of 10 shillings a week to attend Woolwich Polytechnic to do a drawing course. This upset my mother as it was less than the £1 a week I was receiving at the studio. When I pointed out that the course gave me a deferment and that if I was called up she would receive nothing, she relented. I did the course, which consisted of architecture, anatomy, perspective, life and antique drawing, with a shortage of instructors. We had just two: Mr Matthews, a potter, and Mr Buckley, the headmaster. They set the subjects and then disappeared, but because of my studio experience I was able to instruct myself and did well in the exams.

I used pen and ink diluted to make a wash over carbon and lead pencil. Most of what I submitted for my election to the RWS were monochrome drawings, occasionally tinted with coloured inks and watercolour. I found this method suitable for working outdoors for research. I rarely painted outdoors; only in the studio.

I began using oils when given a commission to paint a fire screen for a nurse in my mother's ARP unit. I did a design of a goddess flying over a mountain in classical Greece. The nurse loved it and bought me the paints and brushes. Then I stupidly painted the mountain in the style of Cézanne, and I left out the goddess. The fire screen was nothing like the original design. The nurse disliked it. It taught me two lessons: once a design is accepted, don't change it, and be careful of one's influences.

I used oil paint to create memory paintings of where I lived. When I went out drawing I was taken for a spy by a policeman and had to stop. So I relied on my memory thereafter. Like Turner, Mr Buckley liked what I did and suggested I send my work to the Royal College of Art in Ambleside.

My only experience of painting came from the National Gallery, which only showed war artists' work. Nevertheless I was impressed especially by Stanley Spencer and Eric Ravilious. So I sent war subjects to the RCA; mainly conté pencil drawings washed over with inks, watercolour and white on cartridge paper and oil paintings of air raids. One composition was of the rescue of an injured man from a bombed-out building. I based it on a painting by Piero della Francesca, which I had seen in a book. It helped me to get into the Royal College, where I went in 1947 after my service in the RAF.

The college was crowded with demobbed students, and it was difficult to get any instruction. Fortunately I was able to visit Italy and what I saw there helped me to decide what I wanted to do. I decided to become a mural painter and tell stories about people, places, events, work and games.

I discovered acrylic in 1960 and found it ideal to work with. It simulates watercolour, gouache, tempera, even oil. I mainly use heavy watercolour paper and fashion board.

George Devlin

I feel deeply privileged that I am an elected member both of the RWS and its Scottish counterpart, the RSW. This duality gives me an unusual perspective on watercolour painting, since the Scottish society is characterised by somewhat more abstracted works in its exhibitions, whereas the RWS often evidences the strong traditions of an art form which, after *all, could be said to have evolved almost uniquely from England's 'green and pleasant land'. It may be said that the climatically more dramatic landscape of Scotland injects a heightened awareness of tonal mood and of colour intensity, while the more rugged terrain influences its artists' sense of texture and subsequently their qualities of paint surface.*

Like many artists I work in a range of media as the concepts seem to dictate. At one point this triggered a series of etchings, since I sensed a poetic connection between the bite of acid on metal and the sea-eroded foreshore I had worked on. Another such occasion gave rise to a series of ceramic sculptures, as seemed appropriate. Equally, I believe that if oils are the full symphony then watercolour is the string quartet and is therefore charged with that delightful frisson of working expressively and precisely with the bare bones; a high-wire act with no safety net.

However, my use of watercolour is not limited to the joy of working with translucent paint on fine paper, an experience I have come increasingly to enjoy. I suspect this specialised indulgence relates back to working in stained glass, my craft option as a student. I sense a strong similarity in the luminosity of both media, which moves me deeply. I have a dream of taking large watercolour sheets into Reims Cathedral and simply responding in whatever way feels right; coloured light and washes where even the gloom seems to glow, and the darks resonate like a Bach toccata.

Another branch of my 'watercolour' is gouache, a rather subtle medium and one where I will on occasion throw caution to the winds and let the materials propose

Far left: **Fruit Market, Rialto** 2007 watercolour 21 x 31cm

Left: **Boats at Lagos** 1995 watercolour 41 x 51cm

Below: **Suzette** 2011 watercolour 21 x 31cm

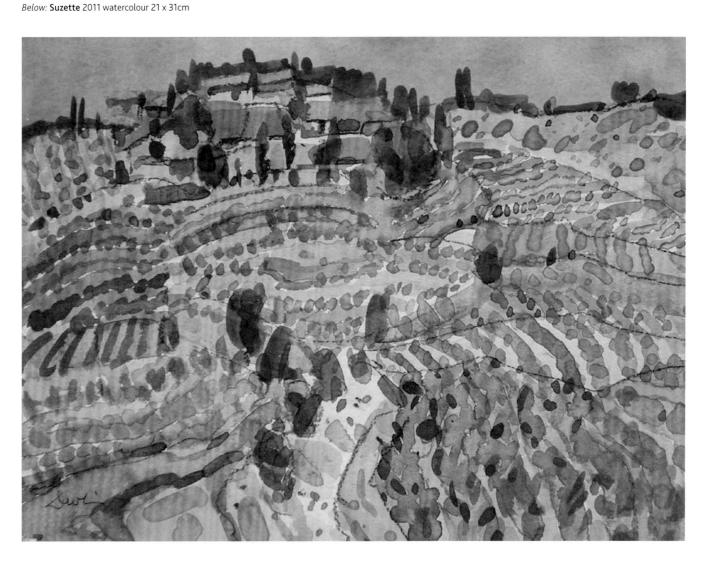

their own use and expression. Household emulsion white, spatulas, wax, and torn paper are allowed free rein to come to terms with the brooding grittiness of the highland Scottish landscape, a landscape often charged with presences of its own history: of toil, tears, wild joys and whisperings borne by the wind. All of the above are largely excluded by preconceptions, which generally result merely in painted views. I believe it is essential to be open, receptive, and to trust in what might follow, alien as it may at first seem.

Though the above may sound ambiguous, I like to recall that around my daughter's third birthday she and I went for a walk in the pristine overnight snow sparkling in crisp morning sunlight. She kept launching herself into the snow saying that she wanted to 'catch the glory stuff'. Her dim father eventually rationalised that she was referring to the impact of spectrum light reflected by snow crystals but she, the true artist, had gone for the jugular of totality. I like to think that I seek the glory stuff in, or as, subject matter.

John Doyle

To be a successful artist today, it is necessary to convey ideas. Perhaps this has always been the case, but today's ideas are different from those of the past. They are at once more outspoken, and depend on sensation, love, hate or, when one thinks of Bacon, horror and disgust.

That I do not fit into this scenario is fairly obvious. I do not despise modern art; much of it I admire, some I even love, but I cannot create such abstract ideas out of my head. I am a prisoner of my own perceptions and to depart from them spells disaster! My paintings are made with little conscious thought. The sensations that a subject invokes in me are carried from the brain, down the arm to the fingertips. Monet said he 'painted as a bird sings', a description that admirably describes my feelings.

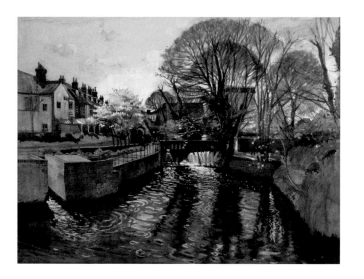

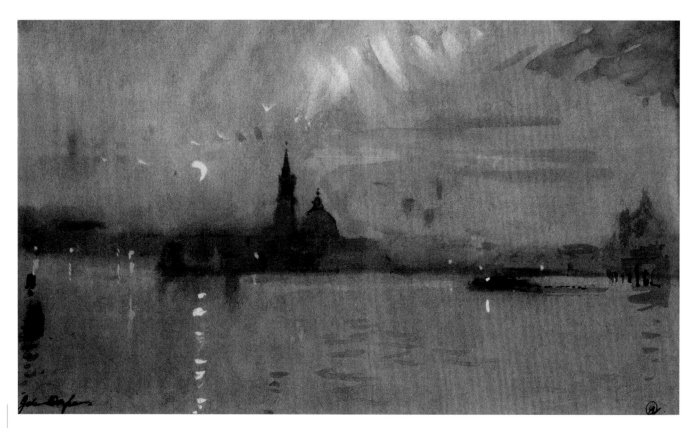

Left, top: **St Radigund's Lock, Canterbury** 2009
watercolour 56 x 41cm

Left, below: **Moon Rising over San Giorgio** 2000
watercolour 23.5 x 13.5cm

Right: **The Temperate House, Kew** 2008 watercolour
56 x 41cm

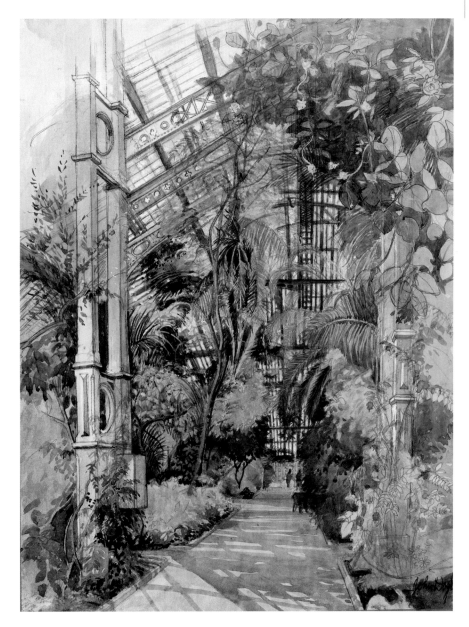

It is possible to teach someone to draw, to develop skill and craftsmanship, but to teach them how to convey their love and passion to others, always assuming they have such passions to convey, can no more be taught than wit.

The artist sees the world with deeper emotions, more highly developed awareness, more enhanced passion than the norm, and upon the ability to convey these emotions rests the greatness of the artist. This, of course, applies to music, poetry, writing, indeed to all art. For it is upon these principles that art itself stands or falls.

Gustave Courbet was once asked how he chose his subjects. He replied: 'I get on my donkey in the morning and when he stops I get off and paint'. I don't find it as easy as that. It is true that a great painter such as Courbet could find a picture almost anywhere, but I have to search, to look, to explore. Oh the agony of the search! It is only when a flash of insight strikes – a sunset, light on the water, a beautiful face – that the necessary adrenalin is created. Then that first moment of inspiration must be carried through the process of creation until the work is done.

It is true that to express these emotions one has to acquire the necessary skills to carry them out, although, as in most things, there are exceptions. The skills needed to express the emotions of, say, Edvard Munch, or some of the works of William Blake, are present in a child but these, as I have said, are exceptions. However, this does emphasise the importance of content over skill.

To be good, art depends on good drawing and knowledge. Endless hours of drawing, endless studying from life, a dogged determination never to give up, are just as important as talent, which is a fragile thing that withers without practice. It all boils down to character in the end.

I can offer little advice to those starting out to paint. Good brushes are essential, ones which come to and retain a point. Paper is also important. Many modern papers are not properly sized and their surfaces are unsympathetic. I stretch my soaked paper on to my drawing board with gum strip, but John Piper used to say he wanted to tame the paper and never did this. The only use of rules is that they must be learnt before they can be broken and, after years of painting, most of them are!

Jim Dunbar

I trained using oil paints; watercolour was rarely mentioned. From my college days until 1999, I used oils for any serious work. My attempts in watercolour never really lived up to my expectations or hopes. In 1999 I left teaching through ill health and as part of my recovery decided to make a concerted effort to learn how to paint with watercolour.

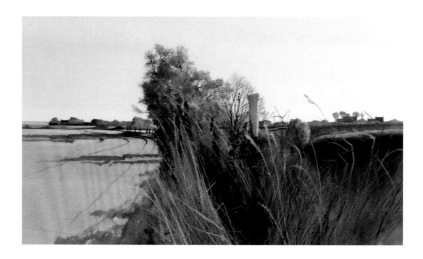

The first thing I did was purchase some good quality paper, paints and brushes and almost immediately I could see progress. I practised graded washes and a variety of techniques using simple subject matter from my garden.

As my confidence grew, I began to record my local landscape as I had done often in oil paint. I soon developed a system of working on site and transporting all my gear. A modified WWII rucksack to carry my half-box easel, homemade palette, and a fisherman's brolly to protect me from the fierce east-coast winds – I use the same kit to this day.

My favourite paper is either 200lb or 300lb NOT white Saunders, which I stretch. This is mainly to protect the paper as I often cross fields, ditches and fences. The pigments are carefully selected for permanence and are artist's quality tubed Winsor & Newton. I restrict myself to 12 colours and find with this range I can mix all I need. The brushes are a range of top-grade sables, two hakes, some cut-down DIY brushes and a lining pen.

I live on the north-east coast of Scotland and have been painting the shoreline and surrounding Angus countryside for over ten years now. I am constantly finding new material from fields I have painted often. I choose a day with good light and walk for a few hours, noting anything that attracts my attention. From these scribbles, a couple of ideas surface and I usually follow these up with further drawing. At this moment, I make some basic decisions about likely composition, direction of light, exposure to the weather, and, crucially, the time of day.

Armed with this information I now have a reasonable grasp of the subject, the scale of the painting and conditions. This all helps to focus my attention so that I can go to the site with confidence, knowing what to expect and so avoid wandering around the countryside 'looking for a painting'.

This method of working suits me well and often one painting leads to the next. Painting on site for me produces pictures that are much more vital and direct compared with studio-based work. The immediacy and urgency of working outdoors encourages a bold statement and I try not to fiddle with the study back home.

I find working from photographs sterile, so I always try to work from sketches in the first instance. However, occasionally, due to weather conditions I struggle to finish a piece without reference to a photograph – not something I am happy to do.

Over the years, I have been careful to make every effort to use sound, reliable methods of applying paint, in both my oils and watercolours. I have spent much time researching all aspects of the permanence of pigments and grounds and the use of acid-free papers, mounts and barrier papers for framing. I firmly believe that as professional artists, we must do all we can to create work using only best practice and tried and tested materials.

Left: **White Marker Balhousie** 2012 watercolour
70 x 42cm

Below: **Winter Plough, Craigmill Den** 2012
watercolour 95 x 41cm

Bottom: **Cornfield, Travebank** 2012 watercolour
70 x 43cm

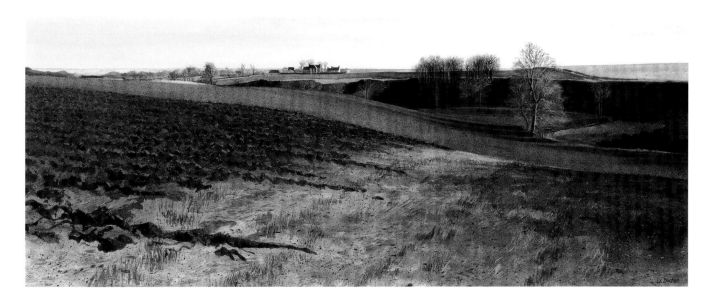

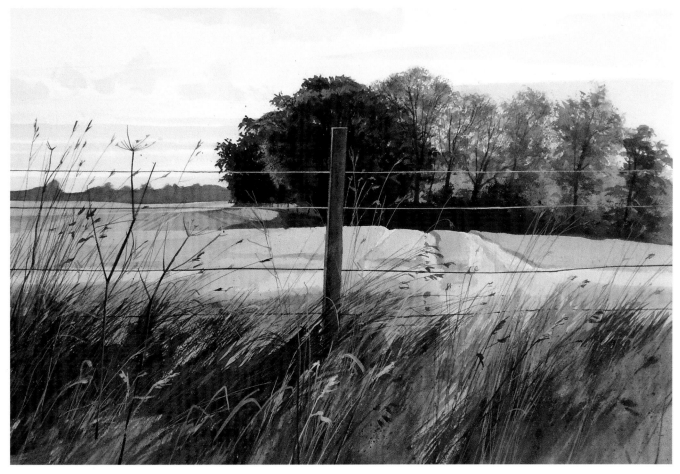

Anthony Eyton

Watercolour is a marvellous medium: colours, water and the whiteness of paper are so conducive to capturing light. At its best, the artist will use watercolour paint in such a way that they reveal its elemental nature; the colours may be almost translucent.

The whiteness of the paper plays its part, almost as much as the marks made on it. The end result will be a wonderful combination of the interpretation of real light and the suggestion of light within the painting.

I find the medium of watercolour can express an idea or a space in the most economical way. It's a kind of summing up, and a wonderful synthesis between vision (brain) and the hand. I also find that watercolours are ideal for travelling as they are so portable and malleable.

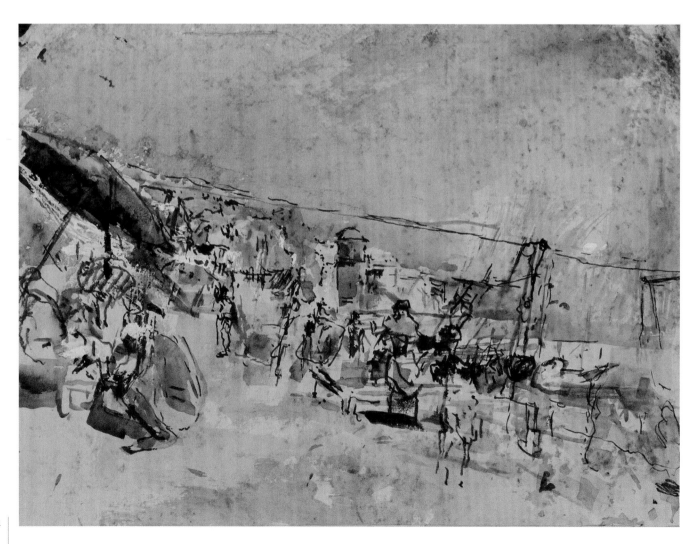

Left: **Riverside with Blue Umbrella, Varinaasi**
2007 watercolour 36 x 50cm

Right: **View of Temples and the Ganges** 2007
watercolour 49 x 66cm

Below: **Bathers in the Ganges** 2007
watercolour 41 x 56cm

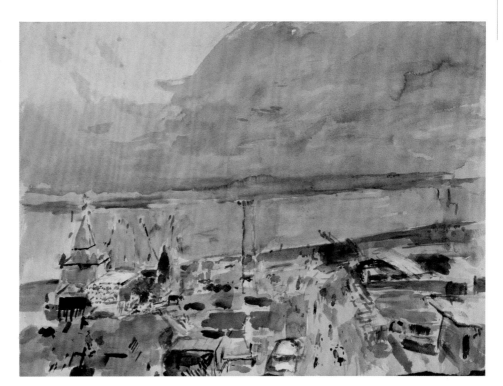

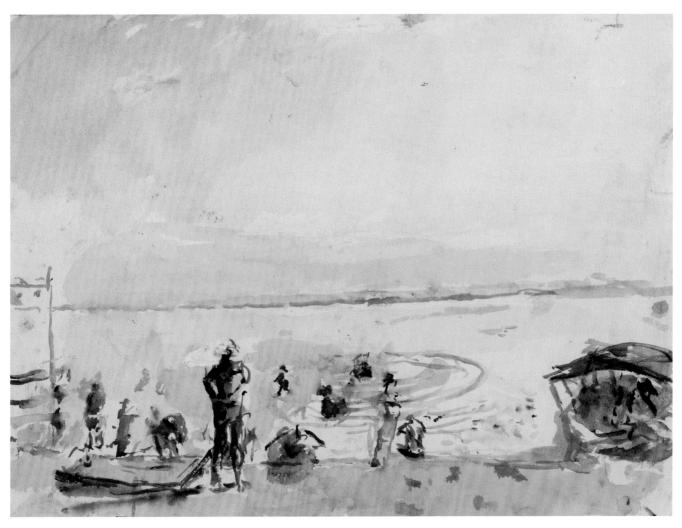

James Faure Walker

Achieving results in watercolour takes some doing. It is a wonderful medium, and when everything goes right it looks luminous and airy. That is what I aim for: to make it look effortless. But it does depend on luck, and a lot of patience. I have a studio routine of making at least one large drawing a day, and that drawing can be in felt-tip or watercolour. By 'drawing' I really mean calligraphy, a fluidly coiling line, which could also be made in oil paint, felt-tip, or in a paint programme.

I have been drawing on the computer since the 1980s (these days directly on the screen through a Cintiq tablet); this has led me to work more freely in other media. I may photograph a watercolour, play around with it in software, and then re-introduce it into a large-scale painting. Occasionally I begin with a motif – a Portuguese plate, a pigeon I have photographed – but I don't normally begin with anything in mind, apart from thoughts about which brush to use and which colours (I limit this to three or four). In my case watercolour is unforgiving, and doesn't allow for revision; whereas larger-scale paintings or digital pieces can take months, or years. But I hope they still look like they just 'happened' in moments.

My influences have come from all sides. At St Martins I encountered Anthony Caro, Leon Kossoff, William Tucker, Gilbert and George; later I got to know Patrick Heron, Bernard Cohen, Irving Sandler; I met some of my heroes such as Robert Motherwell, Al Held and Frank Stella. More broadly: Iznik ceramics, Greek vases. I collect how-to-draw books of the 1900–

1960 epoch. I look at paintings of all kinds: my top ten would be Rogier van der Weyden, Goya, Delacroix, Turner, Bonnard, Picasso, Matisse, Still, Dubuffet, Tapies. Within digital art, there would be Roman Verostko, Yoichiro Kawaguchi and Anna Ursyn. In the night sky, the Pleiades.

I connect painting with freedom. I am sceptical of terms like 'abstract' or 'computer art' when they lead to a separatist way of thinking. I have always integrated the digital with the painterly; it does not trouble me that a red splodge could be a tomato or a circle. I have written on these topics, but not to produce explanations, or worse, justifications.

Far left: **Study 2** 2012 watercolour 76 x 56cm

Left: **Faience Soldier, Lisbon** 2010 watercolour 76 x 56cm

Above: **Still Life in C** 2013 watercolour 76 x 56cm

Sheila Findlay

My painting is based around the themes of still life, landscape and interior that I render through a combination of observation, memory and imagination. I find my inspiration around me in the familiar objects that I have collected over the years, in my home environment in Kent, and in the landscape of Scotland where I grew up.

I like the richness and fluidity of watercolour, the spontaneity it allows, and its flexibility. At Edinburgh College of Art I was taught watercolour and still life in the Scottish tradition. John Maxwell encouraged me to work freely with watercolour and pen and ink, in a poetic and lively way, washing out and even plunging the entire image in water. William MacTaggart encouraged me to lay watercolour directly onto the page, letting the colours run and mingle with each other. I also studied stained glass and mural painting. The English artist Leonard Rosoman taught me a great deal about colour, composition and design, and encouraged me to work on a larger scale combining watercolour with gouache and ink. This inspirational teaching still informs my approach to watercolour today.

Before each painting I work on a freely painted, full-scale 'rough'. I really enjoy this stage, it is a chance to commit to paper initial ideas for the image and experiment with different possibilities as I engage with my

Top: **Seafood and Shells** 2009 watercolour & gouache 74 x 106cm

Above: **Rooftops, St Ives** 2005 watercolour & gouache 74 x 106cm

Right: **Tulips in Edinburgh** 2004 watercolour & gouache 74 x 106cm

subject. The immediacy and energy in these uninhibited exploratory pieces will hopefully carry through into the final work. Being bold at the outset of the painting is essential if I am to achieve the impact required and retain a direct and lively quality in the final painting. Working through ideas in this way enables me to do this.

I prefer to use good quality heavyweight paper, leaving the rough edges showing. This seems to allow a greater sense of freedom during the early stages of the painting. With the paper on the floor or on a table top, I mix up plates full of pigment and lay in large areas of watercolour using long-handled flat brushes. Applying bold washes of colour, I set down the main components of the composition. Walking around the painting, viewing

it from different angles and from above, I consider it in abstract terms. When it is dry, I place it on an easel and start to work into the image in more detail.

I work directly in front of my subject, drawing with a loaded brush. I build up the composition using distinct areas of colour, working to establish a sense of atmosphere and balance. Contrasting busy and calm components I make adjustments, guided by a concern for pictorial effect rather than realistic transcription. During the process of painting I may move from my initial point of reference and make changes at any stage, by sponging out, or by adding entirely new elements.

The choice of colour for the sky in *Seafood and Shells* serves

the composition pictorially and emotionally, creating an atmosphere that transforms the image. In *Rooftops, St Ives* the uninterrupted rectangle of blue sky is set against a cluttered view of rooftops, the bright sunlit feel further enhanced by the dark walls of the busy interior scene. In *Tulips in Edinburgh*, I decided to paint vibrant coloured flowers against the marvellous blue of the moonlit sky. A dark olive green for the studio walls was chosen at a late stage to unify the entire image. Paintings within the painting echo the low tones and bright colours, and the interplay of rectilinear and curved elements throughout. A landscape of rolling hills with flowers in the foreground is shown propped on an easel, contrasting with the Edinburgh cityscape beyond.

David Firmstone

Since coming to live on the Isle of Wight, my work is concerned with land and seascapes. The paintings are also concerned with incidents that take place in the landscape, such as marks made by farm workers with their agricultural machinery or people in the landscape. These small events give my work scale and an element of surprise. Richard Cork, the art critic, said of my work that it had a quality of romantic surrealism, which I hope sums up what I'm aiming for.

I work on a large scale as this allows me to pour paint, creating accidents that I can then control and use parts of in the finished work. I am interested in the quality of surface and creating different grounds to work on, often making highly textured surfaces with gesso and pigments which I then score into with tools, knives and a small sanding machine with which I draw into the surface. The aim is to give each painting a worked appearance before I apply the paint. This has roots in history from looking at the Italian frescoes and the distressed surfaces of buildings.

This information is collected in photographs and drawings that I use to inform the paintings. I stretch very heavy paper that will take the gesso and the sanding techniques. After I have prepared my surface I draw with a paintbrush onto the paper. I have many brushes, including large ones that I purchase from a hardware shop. As the painting progresses, the size of the brushes decreases, ending with a very fine brush so I can paint the detailed passages on small areas of the painting. I like a bit of detail in my work. I work both *en plein air* and in the studio and often on a flat surface to take the pouring paint, leaving it to dry overnight and in the morning discovering what happy accident has occurred.

I often add gouache or acrylic paints to my watercolour paintings. I also enjoy working in series of three paintings at a time. I hope that each series informs the next, but it doesn't always work out; the trick is to paint every day until it's second nature. Could there be a better way to spend one's life? I don't think so.

Far left: **Howling at the Wind** 2011 watercolour
112 x 112cm

Left: **Fishermen, White Cliff Bay** 2012 watercolour
112 x 112cm

Above: **Two Clouds, Italy** 2012 watercolour 112 x
112cm

Tom Gamble

The beginning of my creative life was in 1938 when I obtained an apprenticeship in signwriting with a large painting and decorating firm in Stockton-on-Tees. I still use some of the skills I learnt there in my watercolour work. The use of rhythmic line with both brush and pen is the direct influence of using signwriter's brushes

Overglazing I use constantly – a technique springing from the craft of decorative painting, especially graining and marbling. By this method I produce a range of subtle greys. This technique was also used by Sydney Nolan, likewise trained in painting and decorating, as was David Roberts.

Below: **Blast Furnaces, Teeside** 1958 watercolour
33 x 23cm

Right: **Bertha Richter's Puppets** 2010 watercolour
59 x 47cm

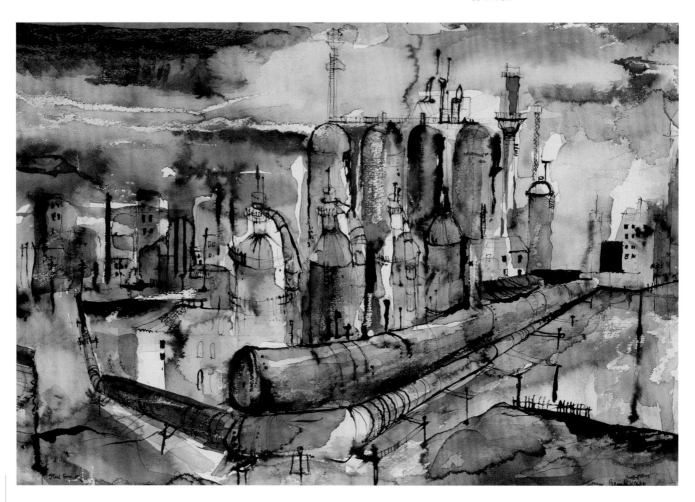

The medium I chose many years ago was pure watercolour, a difficult choice as it turned out. It was quite different from my experience in oil paints, varnishes and gold leaf. I was determined to explore all the possibilities of the medium, the exquisite beauty found in its translucent qualities. I am not a purist in that I sometimes use quite unorthodox methods in order to push the medium to the limit. When it works the experience is sublime.

My apprenticeship included a study of historic architecture and ornament. This cultivated an intense interest that has never left me.

Buildings demonstrate the history of the world. If you look at them they will shout back at you. I still possess a sixty-year-old, well-thumbed copy of Bannister Fletcher's *History of Architecture*. More recently, S. Giedion's brilliant *Space, Time and Architecture* – a study of buildings in landscape by Turner and others – has been a powerful influence.

My own work in urban situations reflects early beginnings in north-east England. Here heavy industry on the borders of the stunningly beautiful North Yorkshire Moors National Park demonstrates a world of stark contrasts. All of this has influenced my work.

When I visit a place of interest, I do so with a small sketchbook of stout paper and a camera. Having made records of the area, I return to my workshop with the information and with the aid of an A2 sketchbook I construct various compositions based on these studies. The finished work is not a view of a place, but could not have been created without the notes as well as the experience of the music, smells and sounds of the city streets. I rarely include figures in my watercolours, though I like to think that some observers of my work may find themselves as the people in the streets.

Janet Golphin

Colour and composition are my basic components, building and twisting, making them work as the painting evolves, tantalising and cajoling the viewer, causing them to work and to think. Simply, this means creating a heart and soul, giving a voice to the subject with gentle distraction in abstract whispers of other pattern or form. Creating a melody, which can be spellbinding or even evoke a smile. Opening with a visually strong image, enough to grab your attention until the rhythm of the basic melody sneaks in, taking your gaze through and beyond. In addition, just as you turn away, its vibration seduces you to glance back and the symphonic arrangement of colour and form repeats as you absorb the rich content.

Left: **Paper Dragon** 2012 mixed waterbased media
65 x 65cm

Right: **Scarlet Ribbon** 2012 mixed waterbased media
81 x 71cm

This is the intention and sometimes the reality, but for every painting that sings the song completely in tune, there is a heap of work that is less harmonic. However, that is allowed and even necessary, because at the moment of despair, triumph is never far away, subject of course to patience. In addition, painting on song for long periods, preparing new work for exhibition can be emotionally draining, and a fair amount of dross then needs to flow before reaching a new seam of ingenuity.

To describe my work as flower paintings would be less than correct. Though flowers often form a central pose, their elevation is to create presence, and I particularly love amaryllis and gladioli, closely followed by lilies, for their ability to allow for distortion or exaggeration. Still life does not have to be formal or obvious, though sometimes the obvious can be reinvented.

I cast amaryllis, gladioli and lilies as central figures of beauty and personality. In addition, as an artist may use the same model often, my three beautiful ladies of the flower world are dressed and posed with similar repetition of strength and attitude. Other objects may hold supporting roles to balance the overall composition, but pattern and design could be used also – whatever makes the song. Using textiles to balance colour, surface design and textured impressions builds the illusion of layers.

In *Scarlet Ribbon*, the flower was reproduced from earlier drawings I have used often; the fan too came from earlier drawings. The textiles came from observation of how nature is a natural designer and colourist. Every element is put together to generate harmony and style. Simplicity against a contrast of intricacy, delivered with complementary tones. Nothing is for its own sake. A presence is held with dignity and style by the beribboned stem and flower. During deliberation I feel the positive vibration as soon as its harmonising song begins to stir. Duplicating my earlier description, the close connection I feel when my work is on song, this is the secret ingredient, the heart and soul and the art of illusion creating physical emotion.

Observe, draw and familiarise yourself with the colour wheel, as the art of illusion must have solid foundations. But a word of caution, be careful where you take your still life experimentation. Are you ready to experience the emotion to be unleashed when you too begin to sing from a similar hymn sheet?

Isla Hackney

I like the unpredictable and provisional nature of water-based paint. Like a landscape, it is transient, shifting and seems to be always in motion. It encourages me to take risks and improvise. I begin each work by sweeping a loaded brush across the paper, or by pouring paint and letting it run. I enjoy the process of painting, and abandon myself to going with the flow as I get a feel for the painting and a sense of the direction it may take.

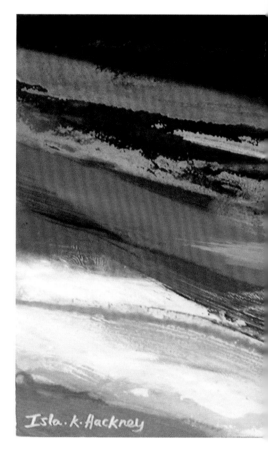

Right: **Fast-Flowing River** 2007 acrylic 28 x 74cm

Far right: **Along the Shore** 2007 acrylic 15 x 20cm

Time is central to my experience of landscape. A sense of the time I spend in the actual landscape and the time taken to make the painting back in the studio is embodied materially in the layered surface of the painting. I am fascinated by our emotional and imaginative response to mountains. The simple mountain motif lets me describe what it is like to visit and re-visit a memory of a place, re-imagine it, and consider the similarities and differences with each encounter. The subject – a mountain exposed to the elements, immersed in shadow or bathed in sunlight – is recreated and amplified in the act of painting. Colours are heightened to create a sense of mood. Dripped and poured paint serve in the description of the scene but also represent the way in which the painting is made and the time involved in making and looking.

Although painting forms the central part of my practice, it has encompassed time-based media and a multi-disciplinary approach to landscape. Having completed an MA in Fine Art at Edinburgh College of Art and Edinburgh University, I undertook a further MA in video theory and practice in Kent, and taught Visual Theory to film and photography students. My diverse training and experience continue to inform my approach. I still move between my studios in Edinburgh and Kent, drawing inspiration from the rivers and glens of Angus where my grandparents farmed, and the chalk downs and estuary landscape of Kent where I spent my childhood.

I work on the floor, painting directly onto unprepared watercolour paper torn from a roll. With plenty of paint close at hand, in open jars and on plates, I work in a bold and spontaneous way, usually beginning with random mark-making. I manipulate the paper, allowing the paint to settle in pools or to spread. Sometimes I blot it with a sheet of paper, or use a damp sponge to remove paint when it is partially dry, leaving suggestive traces and residue. Acrylic paint, used in a liquid form, enables me to wash out, rework and retain remnants of underpainting. Speed of application, directional emphasis and the way that one mark works against another play a part in building the image. Exploring multiple possibilities and mishaps, I

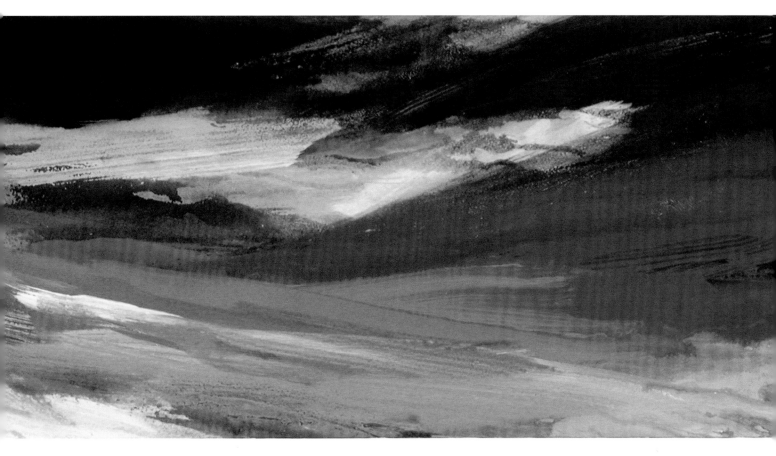

make adjustments as I return to the painting repeatedly.

Although I work on a large scale to convey the immersive quality of my subject, I also like to work on a small scale and find the interchange between the two useful. In *Along the Shore* small accidents of colour and discrepancies in the paint serve to punctuate the image. The scale of mark in proportion to the size of this small work is something I seek to emulate on a large scale. Thrown and dripped paint evoke drifting mist and add drama to *Autumn Evening in the Mountains* (p.12) while the wide format of *Fast-Flowing River* enables a panoramic sweep and breadth of handling on a small scale.

Charlotte Halliday

Architecture inspires me: sun on stucco, classical moulding and the different textures of brick and stone.

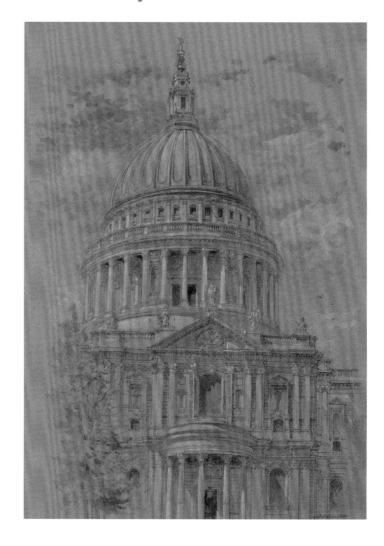

I will wander looking for a subject – on my bicycle in the summer and more probably in my car in the winter. The advantage of the latter is far better visibility through bare branches, protection from the weather and the accompaniment of Radio 4 or Radio 3. The disadvantage, as I rarely finish a picture in one session, is the difficulty of getting back into the same parking space!

Commissioned work brings other problems. Often the building is only visible when there are no leaves on the trees, and surviving in winter temperatures means bulky clothing and mittens. (I was recently painting the Supreme Court in Parliament Square, wearing so many layers that I clearly looked like a down-and-out, for a compassionate young tourist nipped away from his group and put down a ten-pence piece beside me!) When finishing such a picture I still hear the voice of my great mentor, Henry Rushbury (RA, RWS, NEAC), saying '*Believe* in your *shadows.*'

I only work from photographs if absolutely necessary – perhaps to complete a picture at home – because they need so much more interpreting than the real subject. I use a tiny watercolour box – 2¼ x 3 inches –

with a metal water carrier clipped on one side, and toned Ingres paper. Indoors my most important piece of furniture is a pre-war watercolour desk. Out of doors I have for many years depended on my Lap-Ezel, which has a single extending leg and can be strapped to my bicycle carrier.

Since I have acquired my own little garden, I have wanted to paint the flowers that I grow there: the first snowdrops and primroses that are such a thrill every new spring, and daffodils around Easter. Later on, roses, abelia and Japanese anemones

– they have to be blooms with a clear structure. Concentration on a subject inches rather than yards away is an altogether different challenge and the timing is all-important, as one has to learn which will last for days and which for only hours.

Occasionally, of course, I draw my beloved cat, who may get up and leave the room after just minutes. Then I hear the injunction of Bernard Fleetwood Walker (RA, NEAC), tutor at the Academy Schools, urging us to do lightning sketches, 'How things *are*, how things *go*: the ear and the big toe!'

Left: **St Paul's Cathedral from Peter's Hill** 2010
watercolour 40 x 30cm

Right: **The Supreme Court, Parliament Square** 2011
watercolour 30 x 45cm

Below: **St Alban's Abbey** 2006 watercolour 44 x
62cm

Susan Hawker

*Watercolours of landscapes seem to be about places
out there in the real world, about locations the artist
has visited and sketched. In contrast, throughout a
thirty-year career as a landscape painter, my interests
have always focused on the poetic transformation of
the rural environment, not its illustration.*

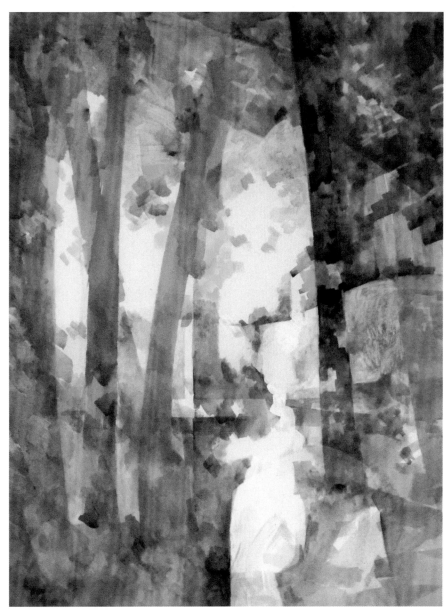

Left: **Woodland** 2012 watercolour, pencil & chalk 33 x 40cm

Above: **Lavilledieu** 2008 watercolour, pencil & chalk 42 x 31cm

Right: **Through Trees** 2010 watercolour, pencil & chalk 63 x 48cm

Since graduating from the Royal College of Art in 1974 I have continually produced pictures in Northumberland, Oxfordshire and the Ardèche region of France, but always ended up depicting landscapes that seem so ethereal and mysterious that it would surely be impossible to actually locate them in the English or French countryside. This non-representational dimension of my work owes a great deal to the abstracted light and space in the late works of Paul Cézanne, but my dreamlike groves of trees and river banks have nothing of his timeless vision: the mood is entirely different. I inhabit the places I paint tentatively, with less certainty about the sustainability of our environment.

When Lesley Worth [President of RWS from 1992–1995] first encouraged me to submit my work for membership of the RWS, I was not convinced that my improvised combinations of water-based pigment, graphite and chalk could be properly classified as 'watercolours' – at that time everything I painted on paper was made in preparation for larger oils. Decades later I find myself a committed watercolourist. My pictures may not conform to the time-honoured English topographical tradition, but I know exactly where every image was painted and I value the power that watercolour has to transform these real-life places, always visually chaotic and full of confusing details, into a unified poetic idea.

Julie Held

I began to paint in water-based paints as a means of exploring and resolving ideas arising from larger works on canvas. In order to begin a painting, I must have a subject. I develop this using drawing and my camera. I begin by stretching (or not, as the case may be) hot-pressed or NOT paper. I paint freely with liquid pigments or cakes of colour. Sometimes I may need to immerse the picture in a bath of water or under the shower to erase areas that don't work, in order to re-imagine the painting until I believe my idea is realised, however much it resembles or differs from the original concept.

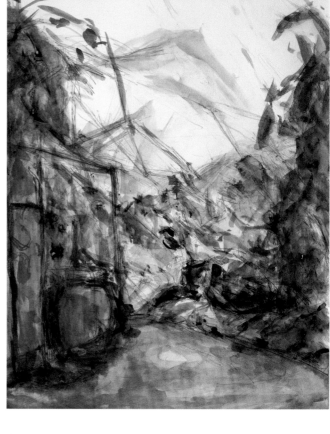

Right: **Eden** 2010
watercolour 37 x 27cm

Far right: **Heat** 2010
gouache 50 x 35cm

I trained in London at Camberwell School of Art and then at the Royal Academy Schools. It was whilst at college that I began to find a voice that suited my practice. This keeps one's approach to work fresh and maintains an ongoing process of flux and development.

Using watercolour helps me to resolve questions of composition and colour choice when I am making a painting on canvas. This does not mean that I don't make changes on the canvas as I proceed, rather that I can see within the watercolour painting several possibilities for the development of the particular oil painting that I am working on. Indeed, the use of watercolour in this way may lead to another, and yet another painting, developing into a series around the subject on which I happen to be working.

I like dark, rich hues, as exemplified in *Heat,* often covering the paper entirely and quickly with paint and thereby denying its whiteness. I know that this is very far from the rule that states that the white of the paper should signify the lightest tone of the painting. I admire Emile Nolde and Paul Klee – artists whose work also lights up a dark spectrum of colour from within.

I consider the line between water-based and oil-based paint to be flexible and often include all of them in a work on canvas. In these instances I work directly onto the canvas with watercolour and introduce acrylic and oil paint at later stages, adhering to the golden rule 'fat over lean'. This is important because it ensures a chemically sound painting and to ignore it would mean that the paint configuration, i.e. the marks in paint on canvas which constitute the image, would crack and flake off with time. These are the only technical rules I consider should not be broken.

Artists whose paintings in watercolour I look to with love and admiration are those who are not known as painters in watercolour, such as Matisse, Bonnard, Beckmann and Rothko, all of whom worked under the canon of Modernism. I consider that my work stems from this rich tradition. Luckily we live in a century when the fluidity of media is infinite.

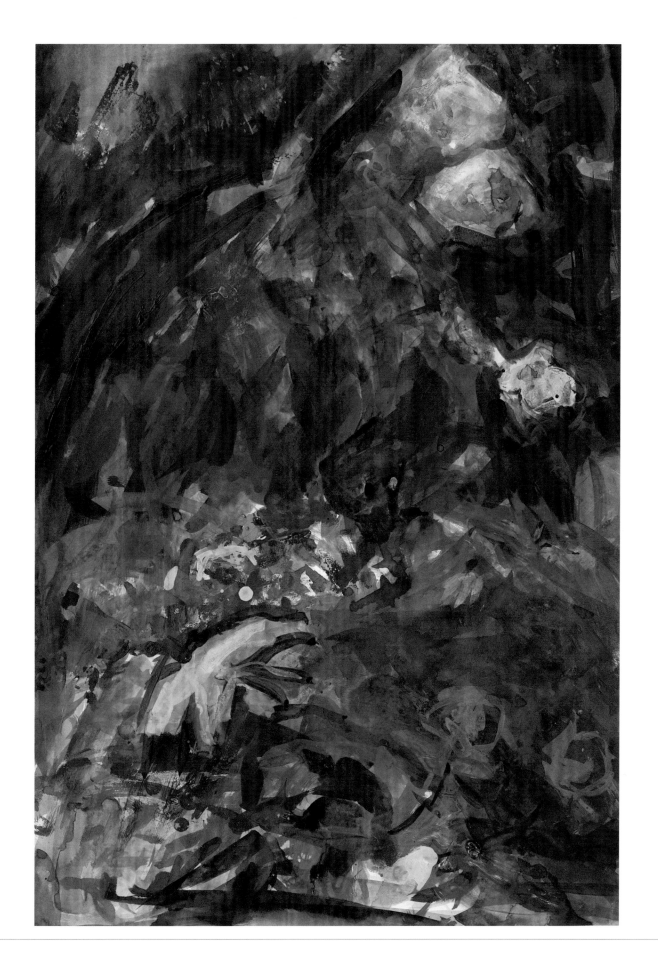

Bill Henderson

I work with acrylic paint all the time, and have done for the past forty years or so. I prefer not to use any mediums or gels these days, enjoying the paint for what it will do for me. The works on paper are not made in preparation for any subsequent work; they are in no way preparatory studies or rehearsals of any kind. They have their own significance for me for what they evolve into during the course of their making.

Auditorium – Black on Yellow and Blink was my contribution to an exhibition entitled 'A Year in the Life of the Royal Albert Hall' (2011), which was installed around the ground floor level of the RAH as a collaboration between members of the Royal Watercolour Society and the Royal Albert Hall. The painting comprises a black mesh of painted lines delineating an oval on a bright yellow ground. The oval is a scaled-down outline of the perimeter of the Royal Albert Hall – the mesh suggests the strings of a musical instrument, maybe, or the buzz of activity within – black on yellow induces an optical pulse between the two.

Yellow, Black and Jazz Me (2011) continues a series of works based on the deformation of grids, in this case of black into white and white into black, the painting becoming more and more improvisatory as in musical improvisation, perhaps, with areas of colour, marks and shapes, shifting the spaces around and within the grid, the grid lines suggesting the strings of an instrument. 'Jazz me' is an invitation to become lost in the picture, as you might become lost in listening to a piece of music.

Orchestry – Magenta, July (2011) suggests a connection with music, magenta refers to the overall colour of the painting, and July was the month when it was started. The words go together because of their rhythmic sound and suggest a further exploration of resonances between paintings and sounds.

My paintings have always had some connection to, or resonance with, music; they also suggest cityscapes, urban spaces, and landscape. I want the viewer to feel able to move around inside the paintings, from one area to another, getting lost in their own imaginings as they do so.

Left: **Yellow Black and Jazz Me** 2011 acrylic
76 x 56cm

Right: **Auditorium – Black on Yellow and Blink** 2012
acrylic 76 x 56cm

Below: **Orchestry – Magenta, July** 2011 acrylic
125 x 150cm

Sarah Holliday

Over the years, my work has moved through various degrees of representation and abstraction. My constant preoccupation, however, has been the conversations between different areas and objects within the painting. In the end, I want the painting to offer up possibilities beyond just what is represented by way of subject matter.

My current work uses still-life objects, all of them things that are special to me and have an intrinsic beauty. They are chosen because of what each one represents in my mind, and they are placed together in a painting to comment on something of note that's going on in the world at that time. The event represented is a personal comment for me, a way of marking something in this age of super-fast news. The challenge of the painting process is then to get these collected objects to sit together in a way that invites contemplation on the part of the viewer.

The arrangement of the objects is not on a conventional table-top – they sit within the picture in a space of their own. Indeed, I aim to create a mysterious space, with a feeling of light coming through from some unidentified source. The objects need to be able to sit together, and the spaces between them need to work. This is the battle of the painting process.

I start with drawings, and sometimes some delicate photo transfer for very intricate things. I work with patches of colour, overlaid in many, many layers, working on the objects and the spaces around them all at the same time, so that they grow together. One of the main errors I see when students are painting a still life is the need to paint 'the object' first and then fill in 'the background' – one cannot exist without the other, and both are equally important. I work with transparent watercolour patches and more opaque layers of gouache. They build up over each other, never completely obscuring what lies underneath. The aim is that eventually an area of colour will be rich and varied – never dull and lifeless. I work on many different papers, so as to not get too complacent, but they are usually a hot-pressed surface (smooth) or a NOT surface that doesn't have too much texture. My paper needs to be strong because I do a lot of scrubbing off and repainting – all part of the process of discovery. Sometimes objects disappear completely from a painting, but their ghosts are always there, under the paint somewhere. That's very important, and very different to not having them there at all, right from the beginning.

I might also have pencil drawing over the paint. I often wipe charcoal over passages, and may also include pastel or coloured crayon. With all this going on, I still aim for a sense of glowing colour in the final painting.

I am not precious about watercolour. It is such a strong and infinitely flexible material – you can jump up and down on it, and it will always come back for more.

Left: **Torso with Bottles** 2012
watercolour 46 x 40cm

Right: **Standing Bottles with Leaf**
2012 watercolour 51 x 54cm

Below: **Bottles in a Row** 2012
watercolour 34 x 11cm

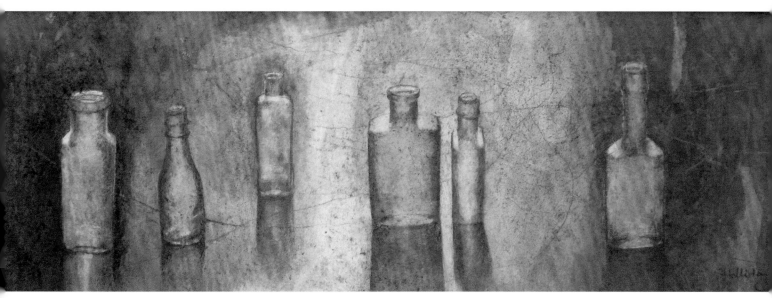

Ken Howard

My main inspiration is light and it is through light that I want to celebrate the world. It is a pity Winsor & Newton do not produce a tube of light, it would make life much simpler.

If, like me, you are a 'tonal painter', to paint light you must also paint dark. On being asked how I got my 'rainy day' effect, I said, 'there is a very good tube of colour – wet pavement in September'. I was of course being ironical!

Above all the painting must be about revelation. Hopefully, we show people a new way of seeing the world. As I believe Kenneth Clark said, 'Art must be life-enhancing'.

Drawing is the basis of everything. All the way through the painting you must be questioning the drawing, right up to the very end. As long as you get the effect you want, that's the important thing.

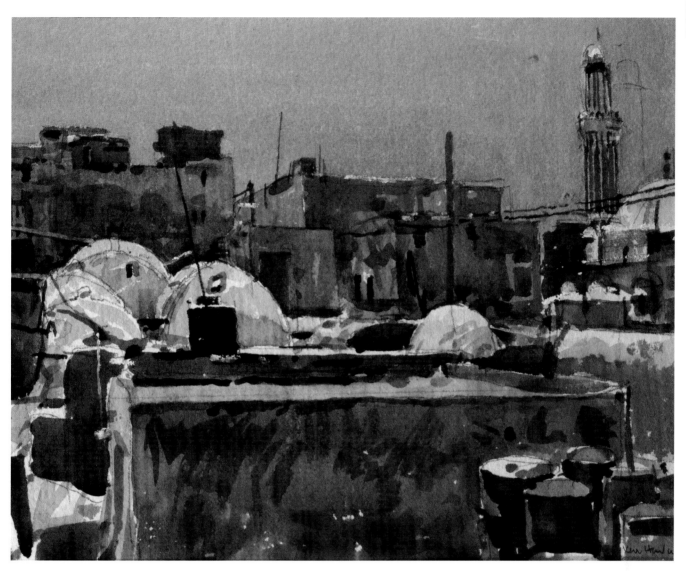

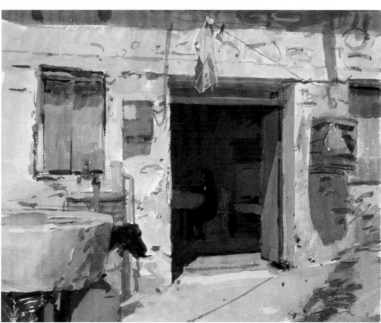

Left: **Sketchbook on an Indian Train** 1986

Above: **Sanna, Yemen** 1997 watercolour 23 x 30.5cm

Right: **Midday Light, Cyprus** 1982 watercolour 18 x 23cm

Jonathan Huxley

These images were made in the dark. I had been staying with a friend whose son had been missing for over two weeks. I remember waiting in the house for him or the police to call. Being kept in the dark indefinitely is draining to the extent that we just wanted to sleep, to avoid the feeling.

After days of this I went to the studio with the words 'missing persons ' in my head. I made these images using 'invisible' ultraviolet paint: you can only see them in the dark with an ultraviolet light. Any further narrative would be misleading. I painted them quickly, in one sitting, in the dark. Much of my work on paper is produced in a condensed period of time. I try not to think too much about the reasons for its existence.

Left, top: **Missing Persons I** 2012 fluorescent ink with ultraviolet light 60 x 17cm

Left, below: **Missing Persons II** 2012 fluorescent ink with ultraviolet light 60 x 20cm

Above: **Missing Persons III** 2012 fluorescent ink with ultraviolet light 25 x 30cm

Wendy Jacob

What is my [watercolour] secret? I wish I had one. But I will share some strategies learnt from wise mentors. The best advice given to me was to keep painting – just do it: don't give in to despair and don't expect every painting to come off.

Imagine leafing through a heap of paintings. Some will be good and some not so good. Judging quality is difficult while the creative juices are flowing. If I am unhappy with a painting at this stage I won't throw it away. I just put it on one side and come back later – weeks, months or years later, and when distanced from the sense of failure, I can sometimes see other qualities to which I was blind before. Because I use gouache with its excellent covering properties, I can wash, or even scrub off the rejected, unwanted painting in the sink and work over its 'ghost'. This is such an ancient and well-used technique that the resulting shadowy image on the paper has a name when it shows through the subsequent work – *pentimento*. This can be the starting point of a new painting that may be stronger, thanks to the underlying structure.

Other advice I try to follow is to keep my eyes wide open and always keep a sketchbook with me. I draw a lot and draw everything wherever I am – the act of drawing reveals subjects and a reality previously unobserved.

When drawing landscape I first draw the obvious to get that out of the way – then I am free to observe other subjects. Drawing makes me really look. I think about colour and, again, look really hard and avoid the obvious, accepted colour my brain has learnt to recognise without conscious thought. I try to notice interesting colour groupings wherever I am and make a note.

What am I going to paint? The subject is vital. It must be something that excites me – then I have to find a visual language to convey that thrill.

I invest time in research and make small thumbnail drawings a few inches square. I used to paint still life, but took up the challenge of landscape and became fascinated by man-made interventions in the environment – ruined factories, chalk quarries, patterns made by structures and the play of light on these subjects.

My current obsession is temporary paling fences put in place for environmental protection. They develop a life of their own, become fragile and vulnerable. After a few months of weathering they make wonderful patterns and shadows. I find them everywhere. Some are close to home, protecting small areas of urban public open space specially planted to encourage sparrows or other wildlife. Others are further afield, stabilising coastal sand dunes in western and southern France and in Norfolk.

Cliff Bayley, RWS past president, once advised me that when in the grip of creative excitement while working on a painting, when ideas keep coming, not to put them all in that painting. Remember the original intention of the current painting and make a note of the new thought or idea and let that become the subject of another work. Thus each painting is punchy, simple and easy to read. As the series continues, often the paintings become more and more intense. When they don't it is time to move on to something else.

Olwen Jones

You are never too young to start drawing. I have always done so since long before art school days, which for me began aged thirteen and a half years. The 'Junior Art School' as it was known provided art classes for half of each day and generous education for the other half; we learnt a lot and grew up fast.

Below left: **Watching Cat** 2010 watercolour 35 x 25cm

Below right: **Morning Room in Spring** 2011 59 x 42cm

Right: **Tropical House** 2011 watercolour 44 x 57cm

Being an only child brought up in London I had a lot of freedom and would make sketches wherever I found myself. As my parents were constantly moving house, there were always new subjects nearby. Buildings of all sorts and particularly railway stations and the yards around them became my havens. A mass of upright lines, endless windows of all shapes and sizes, everything within close proximity. I believe this early experience has affected my outlook in my direction as a visual person.

After completing and passing my NDD in painting, the following three years at the Royal Academy Schools gave me the time to experiment and begin to find my own path towards practising 'art'. I never at any time thought I would do anything else. Painting meant oil or acrylic and it wasn't until the late 1970s that I started adding watercolour washes to some of my pencil drawings. Soon I was using pure watercolour with very little drawing only as a compositional

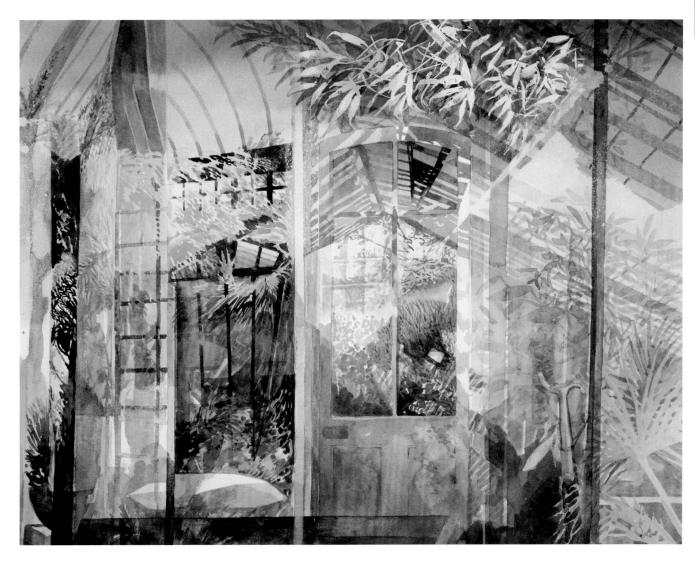

guide. Leaving some of the paper white within the design is important to me: it gives a bounce and luminosity. By using plenty of water with the paint I can achieve layers of transparent colour and increase the range of tones. My limited palette is usually a single primary colour, its opposite and adjacent tones.

I am intrigued with the similarity of opposite, or very different objects and situations. Plant forms within a man-made environment, for instance conservatories and greenhouses; the structure of uprights and horizontals, doorways, windows, cane poles, wire and netting can give plenty of stimulus in design for painting. The complex has always interested me and I will

incorporate two or more aspects or viewpoints of the same subject within a single work. I start by making drawings on location to gather information; this gives me time to clarify my ideas. Back in the studio I plan the format for the painting, choosing size as well as content. I am now ready to start and lightly pencil in the main design on the watercolour paper. With my information drawings at hand I begin to execute the painting. Though I make colour notes on the spot, working away from the subject gives me the freedom to compose the colour subjectively.

I aim to give the illusion of a deeper space within a limited framework. Windows and mirrors can

do this, and can also change the scale within different parts of the painting. How one applies the paint is very personal and I sometimes use stencils which I make myself, in combination with brush work. It is important that the painting remains fresh, though it might have taken several sessions to complete.

Painting is like an individual language. Techniques can be learnt and a good teacher can be a guide along the way. Being skilful does not imply a personal vision; the painter must paint with something to say. Then he or she can rightfully be called an artist.

Janet Kerr

The way my use of watercolour has developed is due entirely to my present choice of subject matter. The particular landscape of the West Yorkshire Pennines has, to me, a characteristic powerful, bleak and distressed look about it, perhaps because it sits on coarse gritstone and is exposed to extremes of weather. There are vast open areas of moorland, dotted with small clusters of activity in the form of farmland or stone-built hamlets, and the range of textural qualities on the steep hillsides is outstanding.

When I embarked on trying to capture all this on paper, I used to sit on the windswept moors, drawing or painting large, detailed tonal studies of panoramic views, religiously 'copying' everything I saw. I may have started to achieve a good grounding in the subject, but I struggled to produce any results that I felt spoke specifically of the excitement I felt for the area. I found that if my reference drawing was too complete, I would feel obliged to copy it when I came to paint, back in the studio.

Then, I was extremely fortunate to be mentored by Charles Bartlett PPRWS, who not only taught me the importance of structure and composition, but also that my investigation into the subject needed to have more purpose, and when working from the subject I should ask myself, 'What am I commenting on?' This was a precious gift! From then on, I re-appraised my approach to the gathering of information for paintings and concentrated on recording only the elements of the landscape that were relevant to my line of enquiry. I started to learn how to see deeper.

As my drawings became more purpose-led, they began to be little more than quick notes: now there was space for me to develop the work in the studio without feeling tied down! I was interested in portraying what it *felt like* to be in this location rather than producing a topographical study. The subsequent drawings could make use of memory, which, coloured by emotional response, would spark creativity for me.

The onsite drawing shown here was made on the hilltops above Hebden Bridge. My immediate reaction to the location was one of the desolate feel of the place. The collapsed drystone wall in the foreground and the distant reclaimed farmland contrasted, and so emphasised this feeling. 'Contrast' was my idea about the subject and I followed this through with the relationships of colour, tone, texture and the size of the main shapes.

The studio drawing was one of five that I made a couple of years later, intending to develop the idea. Although it's not easily readable to anyone but me, this was the starting point for the painting. I first altered the format of the work to a squarer shape as I didn't feel the left-hand side of the original drawing added anything of value to my cause. I then moved the whole composition to the right, in order to improve the balance.

The painting *Hippens* was worked in mixed media, with watercolour, gouache, charcoal, water-soluble crayon and pasted acid-free white tissue. I use tissue in order to achieve the textured appearance of the landscape. Its translucence enables me to paint dark to light in a textural way, instead of the more usual light to dark sequence when using watercolour. The tissue is pasted with acrylic medium, in order to avoid any unwanted yellowing.

The first stage of this painting was to wash the whole of my stretched watercolour paper with Windsor Blue watercolour, greyed with a little Indian Red. I then pasted on the tissue, torn or cut, roughly according to my drawing, and left it to dry. Next, I drew with charcoal to re-establish the intended composition. It's from this point that I begin to abandon the reference drawing, and the painting itself starts to lead the way forward, as I respond to the relationships between the elements of the work, and develop the idea further. The colour and the key help to create the mood. Finally, having arrived at a probable conclusion, I like to put the painting away for a week or so, before having a final check, with fresh eyes, to see if I have achieved my initial idea.

Far left: **Studio drawing**, 2005 charcoal 18 x 18cm

Above: **Hippens** 2005 mixed media 29 x 29cm

Sophie Knight

Much of my recent work has been an exploration of nature: plants, brambles and weeds, set against the backdrop of my own surroundings, the inner city spaces and parks of South London. I like the visual contrast of the twists and turns and organic nature of brambles, wild flowers and grasses exploding onto the page as if from a jack-in-the-box, set against the more rigid vertical lines of the buildings or urban structures which appear on the horizon.

I use a variety of visual aids to help me in the studio, and I always carry my mobile phone, which has a large-screen camera ready to capture any interesting aspect of life. I often hold the phone in one hand, painting directly from a photo on the screen – strangely the annoying way the image flicks off actually helps me, in that it gives me a sense of urgency that is closer to the experience of working outside.

I have never been interested in over-describing a subject; I prefer to suggest the place, whilst allowing the overall mood and atmosphere, paint and general mark-making experience of the painting process to be a large part of the subject. I tend to work wet on wet, I don't stretch my paper but I don't seem to have any problems with it buckling or wrinkling up: it seems fine if you keep it evenly damp. I always spray my paper with a fine mist of water from a plant spray, and then get to work, always working quickly, drawing with the brush. I only use tubes of paint, not pans, because I like to get the paint on quickly, which would be impossible on a large piece of paper with pans. If I want to cover a large area with colour, I usually squeeze a small blob of paint directly onto the paper and then quickly wash it across with a large flat brush loaded

with water. I love this way of working as you achieve a rich field of colour that will not fade into nothingness when the paper dries. If you look at *Beginnings of Summer, Ladywell Park, London*, the area on the wall in the background was created this way, here I squeezed a small blob of Cadmium Yellow on the right and some Burnt Sienna and Cobalt Blue together on the left. When adding water with the brush, you can wash one colour quickly into the other colour and they blend in the middle in a soft way. As my paintings can be very large, up to 6 feet, from a roll of Arches paper, this way of covering large areas suits me very well.

More recently I have allowed some areas to be worked in a drier manner and have also begun to use masking fluid at the beginning of the painting. I use it freely, as if I were painting in colour or drawing with the brush; this has added a different dimension to my work as it allows me to create sharper edges and texture against the softness of the large wet on wet areas of the surrounding background. In *Web of Brambles, London Fields* I drew freely with the masking fluid and splatted it onto areas first. Later I also used pencils and pastels to emphasise the structure and texture of the brambles. Once I have painted on top of the fluid, and let that dry, I can peel the fluid off and only then do I get to see how it looks with the clean white paper revealed underneath it.

If I was to give advice on watercolour painting I would say: be as bold as you can, work in a variety of ways to find what suits you most, but mostly go with the natural flow of the painting. I feel watercolour more than any other medium has a life of its own, it's full of surprises and the best you can do is hold onto your hat and enjoy the ride.

Left: **Beginnings of Summer, Ladywell Park, London** 2012 watercolour & pencil 108 x 80cm

Above: **Web of Brambles, London Fields** 2012 mixed media 92 x 160cm

Karolina Larusdottir

I get my inspiration from many sources but I must admit that a lot are very personal. From Iceland – from my childhood. I may only have a fleeting glimpse of a place or a moment, but as with everything else, sometimes it works and sometimes not.

This is what I love about watercolour: the immediacy and how the workings often call for a spontaneous execution. My favourite artists are Samuel Palmer, Elizabeth Blackadder and Peter Blake, to mention just a few.

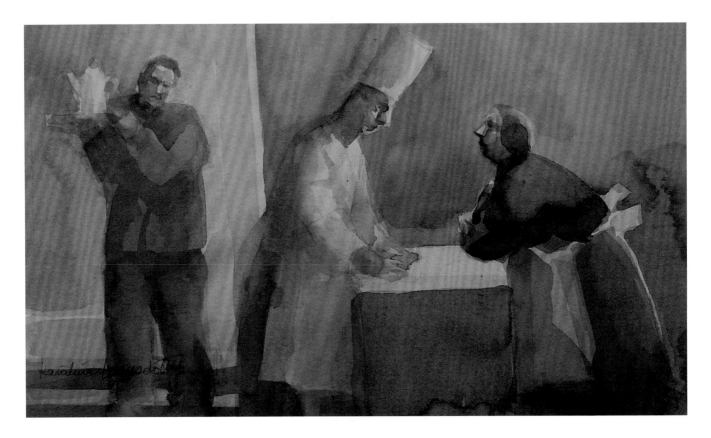

I only ever use Rowney or Winsor & Newton artist's watercolours, which I buy in tubes. I then put them out on a large pan with lots of compartments. These are not easy to come by, but I have had mine for years. I use quite broad bushes for washes – 3, 4 or 5 inches. I like sable brushes as they keep their shape so well.

My choice of paper is 300g or heavier if possible. Hot-pressed paper is completely smooth or silky to the touch. I love the effect it gives as the colours almost run out of control and into each other. Then the question: to stretch or not to stretch? I never stretch. I find it is enough to put the wash over the paper, but then that is also because I use heavy papers.

I usually draw a very fine line on the white paper – very light. Then I put a very diluted wash over the whole page, using mainly yellow and ochre and warm colours for the base. Then ever so slowly I start building up the picture with more loose washes.

I find that taking the painting and putting it behind glass or in the frame a few times while I'm working on it is helpful because it is only then that I can really truly see how it is progressing. Often I see that it is really almost finished and a lot more work would really spoil it.

Left: **Telling Secrets** 2008 watercolour 34 x 48cm

Right: **Cakes** 2008 watercolour 35 x 50cm

Below: **Waiting in the Garden** 2008 watercolour 34 x 48cm

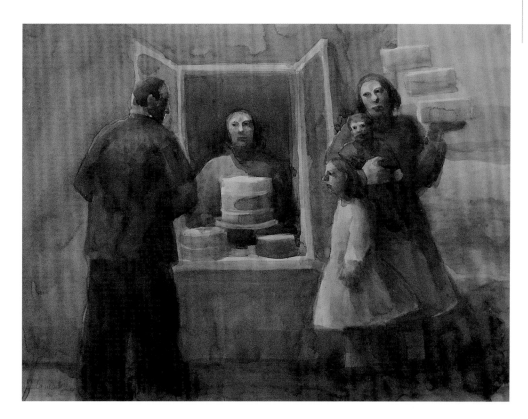

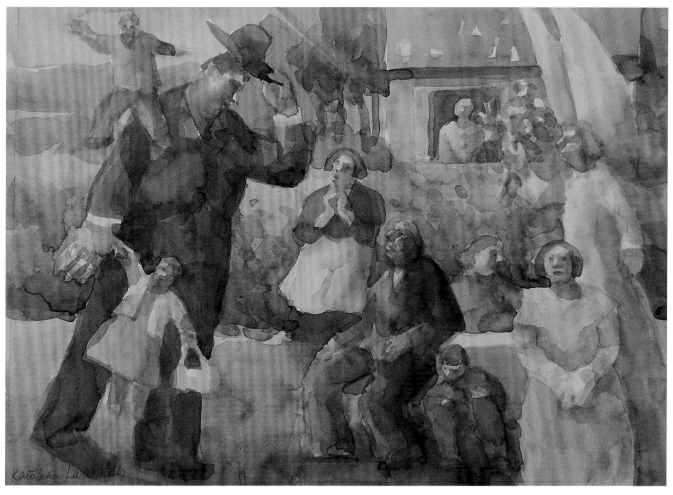

Sonia Lawson

My parents, Fred Lawson and Muriel Metcalfe, were both well-known and respected watercolourists in the north country. So it was that from an early age I loved and respected the medium that is so well suited in its versatility to portraying the strong poetic drama of rapidly changing weather: from sun to snow, a frequently experienced 'drama' in the Yorkshire Dales limestone uplands, an area nearer the Lake District than it is to the wide, flat Vale of York.

My father would venture out in all weathers (deep snow was no deterrent), and return later with a work that was worth the pain. One tip he gave me was to add a few drops of whisky to one's water pot to prevent its contents freezing.

After leaving for London and the Royal College of Art I was, needless to say, influenced by the sheer vibrancy of the city: I was recharged. I don't mean I took up 'tachism' or any current 'ism'; London with its wealth of museums, galleries, theatres and big heart was the invigorating stimulant. My parents had always appreciated Girtin, Turner, Picasso and Matisse to name but a few, so my influences were broad.

Watercolour is a sophisticated medium, not at all easy to work. I struggle along using any good paper, Whatman very often, because it can take a lot of vigorous handling, sable brushes no.3–12 and sometimes a little pen and ink in the practice

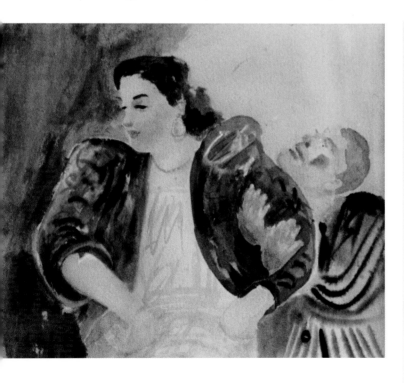

Above: **The Pest** 1990 watercolour 17 x 23cm

Right: **Dolores, Aix en Provence** 2010 watercolour 31 x 23cm

Opposite: **In Your Dreams** 2009 watercolour, aquapasto 25 x 31cm

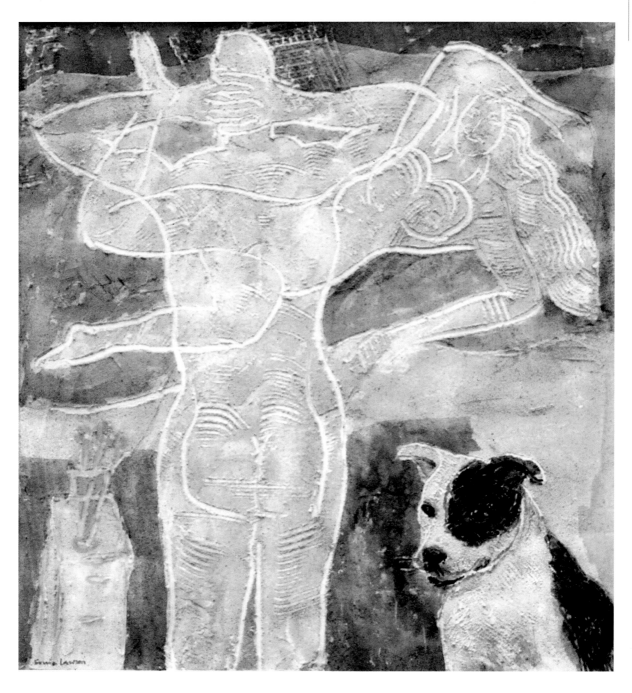

of Paul Sandby (1725–1809). I also use Saunders, Waterford and Somerset, all grand to work on. Sadly the original David Cox's paper is no longer produced. It was a pale buff colour, smooth, very slightly absorbent and didn't buckle when wet. Arches and Rives, both good quality print papers, are perfectly good for watercolour, though they don't stand up to pummelling like a trusty Whatman.

Since 1993, when painting in oils, I introduced Winsor & Newton impasto medium to my paint as well as adding raw pigments. This thickened up my material and when applied to canvas, usually with a palette knife, I could score into the body of paint as a drawing. I can't always free myself from this satisfying method when working in watercolour. My example here is *In Your Dreams* where the figures are 'drawn' in by incisions made into the plump material of the surface. Here I used watercolour mixed with a little plain flour to give it body and added water, gum arabic or a little acrylic gel; however, Winsor & Newton now advertise an impasto medium for watercolour. Of course, pure watercolour handled well gives a valid sense of real achievement, though a bit of duality can be refreshing when the need is felt.

Jill Leman

In my paintings I am trying to coax a new image into existence – to get a response from the painting itself. I need to have a conversation, a relationship with the marks, colours and lines. This makes a difference as to whether a painting works or doesn't work for me.

I take the ingredients for a picture – I'm first attracted by the colour of a pansy, a piece of china, a scrap of material, and then I process it – look, draw, discover how it works. Then comes the excitement of colour, shape, and the making of a new image, an interpretation of what I have seen, emphasising what I feel about it, how I want other people to see it.

So many times my paintings appear finished – but I feel there is a bit of magic missing. Then it is necessary to take the situation in hand – I am the one in control here! I decide on colours and shapes and it is essential to take a risk and go for it. 'Be in the now'

is a phrase I am constantly thinking about when I work. How do I want the painting to look now, and how am I going to achieve the painting I want?

I know when a painting works for me and is finished, but how to describe my working methods? Drawing is very important to me. A drawing can be complete in itself, or used as a preparation to a painting. Looking and looking and drawing and drawing are the best ways to see how a flower is attached to a stem, how many petals it has, or how a building works – how many windows or chimneys. Once I have this information I can simplify, change

and adapt it to create a new image.

I was very fortunate to spend two years at Colchester Art School in the 1960s. Many practising artists were our regular teachers – John Nash would bring teasels from his garden, or green peppers for us to draw. Edward Bawden showed students the linocutting and printing processes and there were many others who taught me how to look and draw – Max Brooker, Roderick Barrett and John O'Connor.

I begin by drawing in a sketchbook, then I can start a painting. I find lovely paper intimidating – sometimes I do use paper but I often prefer mount

board, maybe primed with thin acrylic gesso. When I first started to concentrate solely on painting (I was a graphic designer) I used watercolour exclusively but now I use mainly acrylic paint, thinned with water and scrubbed about. I am only interested in what the painting looks like when I've finished it – how I achieve that doesn't matter. Although I greatly admire amazing technique in others, it's not for me!

Picasso said that every child is an artist, the difficulty is staying an artist when you grow up. My husband Martin and I spent a lot of time in Cornwall during the 1970s and 1980s and met many artists: Breon O'Casey, Terry Frost, Patrick Heron, Wilhelmina Barnes Graham, but the one who influenced me most was Bryan Pearce. His paintings of St Ives, and of flowers and fruit have a very special clarity of vision, a blend of simplicity and sophistication.

Another quote: 'A painting may be done with difficulty but should never appear that way.' I am so happy to do what I do, but it isn't easy. I feel that if you want to do something enough, and are prepared to put in many, many hours' work, it will happen, but not by accident. Paintings don't paint themselves!

Far left: **Souvenir** 2012 acrylic 34 x 34cm

Left: **Pink Table** 2013 acrylic 17 x 12cm

Above: **Self Portrait at Home** 2011 acrylic 31 x 25cm

Martin Leman

'If a man does not keep pace with his companions, perhaps it is because he hears a different drummer. Let him step to the music which he hears, however measured or far away.' Henry David Thoreau

I have spent a great deal of time at the very end of Cornwall, walking and swimming. The place has a certain magic for me – West Penwith, all around Penzance and St Ives. Sky, sea, stones, ships and bits of flotsam and jetsam that I've collected over the years.

My work is about ideas. I work these out as thumbnail sketches and have many small sketchbooks full of ideas. They are my visual diaries. I start a painting from an idea and do some small pencil roughs in my sketchbook – trying to visualise the sort of painting it would make – scale and tone. Then I tighten up and design the composition on detail paper and transfer that to the paper support which I have stretched. I like something solid to work on; sometimes I dampen thick watercolour paper and stick it on MDF with Unibond glue. When it dries out the paper is beautiful – absolutely flat and ready for a coloured ground. I don't like starting on white paper – sometimes I start with black or grey, I am more comfortable with this. I find I am using less and less colour – when I first began to paint seriously in the 1960s my paintings were in very bright colours.

Work on paper is only part of my work as an artist. For a long time I used oil paint exclusively, but since joining the RWS my work has broadened out to include acrylic paint on paper. Acrylic paint has its drawbacks, but also many advantages; for someone like me whose work was mainly oil, acrylic has eased me into a new way of working. You must use plenty of water to clean brushes and always put the tops back on tubes of paint, or they will dry out, unlike oils or watercolour. I suppose you could say acrylic has been the key to unlocking a whole new era in my artistic career.

From my early days as an art student in Worthing and then the Central School of Art, London, watercolour and gouache were part of the work we produced. Later, when teaching graphic design at Hornsey College of Art, gouache was used to visualise colour in design projects – laying down a wash was the only way one could get the required colour.

Knowing the rules and correct procedures is very important, as is spending hours in the life class. I have this as a basis, but a painting produced purely along these lines may well lack that magic ingredient that makes a painting special.

Left: **Garden Entrance** 2011 acrylic 34 x 28cm

Right: **Eleven** 2011 acrylic 17 x 24cm

Below: **Coast** 2010 acrylic 27 x 33cm

Arthur Lockwood

My watercolours are drawn and painted 'on the spot'.
I learnt this way of working from my father, who also
painted in watercolour and took me, aged nine, on
his sketching outings.

I use Saunders Waterford, NOT surface, watercolour paper of sufficient weight (200lb) that there is no need to stretch the paper before painting. I work from half-imperial to imperial and some sizes in between. I draw the basic composition and outline in pencil before starting a more detailed drawing using pen and ink. The only work I might do in the studio is to finalise how figures are included: from observing figures and making quick pencil drawings I usually have enough information to place them in the composition. Painting is also done 'on the spot'.

I use Winsor & Newton watercolour with occasional touches of gouache. If a painting is not going well, I use a sponge to wash off the paint in the areas I don't like and start again. One problem with doing this is that the size is removed from the surface of the paper, which then becomes like

blotting paper, but it is not difficult to put a new coat of size on the paper.

I trained as an illustrator at Birmingham College of Art before studying graphic design at the Royal College of Art. I feel my work is part of that illustration tradition. I worked in London before moving back to the Midlands to paint full-time. My main subject areas are the urban scene and the factory, especially those working with metal. The city is changing the whole time with demolition, new buildings, roads re-planned and areas re-developed. There is no lack of interesting subjects. Traditional

foundries and drop forges are closing down as work goes abroad. I think there should be a visual record of these factories which were once so important to Britain's industrial revolution.

The pen and wash watercolour is my preferred way of working. It is perhaps more typical of the eighteenth century, with painters such as Paul Sandby, John 'Warwick' Smith and Francis Towne also using this method. I enjoy the act of drawing and the pen line is ideal for my aim of making an accurate record of the subject.

There are many ways of working in watercolour and the great virtue of the RWS is that it can accommodate many different approaches, from photo-realism to abstract, from impressionism to illustration.

Left: **Stokes Drop Forgings, Dudley** 2009 pen & wash 42.2 x 60.8cm

Above: **Factory Interior, Hughes Johnson Stampings Ltd, Langley** 1991 pen & wash 38 x 56.5cm

Caroline McAdam Clark

Watercolour is one element in my toolkit for making paintings. I use it as a kind of work-out for ideas and as an aide-mémoire *when out and about with a sketch book. I also use it to make finished works that are essentially studio-based and where my choice of this medium is dictated by the needs of the work itself.*

While I greatly admire the quick-fire skill required to achieve that clarity and delicacy so characteristic of classic English watercolour painting, I am less interested in technique as such. What interests me much more is the subject or idea that I want to share. In my case, this often entails enlisting other media such as pencil, gouache, acrylic or collage into coaxing out imagery that relates to my original concept, or even takes that concept on a surprise detour.

The one constant however, is the support, which is invariably a heavyweight good quality paper. I love the particular qualities of different papers, suggesting different deployments of paint into and across their surfaces. Good paper is very forgiving and will even take a coat of gesso, which I can rake or scratch through with a comb to create a series of ridges or an incised line, making

a sort of adventure playground on which to work. Indeed I frequently paint in oils on paper prepared in this way.

Seeing and drawing new places gives me the impetus to create new bodies of work and expand my personal visual lexicon. So I spend a lot of time on the road, in search of places and imagery that I can use back in the studio; I carry a camera alongside my note/sketchbook. I have a huge archive of photographs, many as yet untapped but all catalogued into their relevant sections: coast, desert, harbour, flora, fauna, people, industry, trees, shipping, buildings and so on. I never take a photograph to 'copy' into a painting; it is there to jolt my memory, to transport me back to whatever it was that originally demanded to be recorded, and from then on it is imaginative recall and my own notes that guide me.

But in order to make sense of such stimuli I have a profound need to know something of the story, the geology and the people of a place to be visited. It is simply not enough for me to come away with a sketchbook full of surface views. There *are* spaces that I already inhabit and feel I know them intimately enough to rely on memory, imagination and those indispensable notebooks. Such are Suffolk, London, the coast around the Highlands and Islands and around Cornwall, the weather, the sea, my books and my 'stuff', collected over thirty years and distributed about my studio.

When recently in Arizona, I read about the history (violent) the geology (astonishing extremes of nature awesome in their scale) the introduction of the mustang, and read (for the first time) Jack Kerouac's *On the Road* and other American classics, to psych myself into opening my mind

and my imagination into making more of what I *would* see than merely recording what I *did* see. I surprised myself, becoming interested in aspects I had not anticipated, such as Navajo and Hopi imagery and pattern-making.

I believe my most successful foray into using watercolour (almost as it was designed to be used, unadulterated) is in a day-book I began a while ago. In it I set out to make a tiny daily visual statement, letting my mind and my hand wander into uncharted territory and create something out of nothing but what I carried in my head that day. Watercolour and sometimes pencil have proved perfect for this very intimate and revealing exercise, and although I have not managed to sustain it as a daily event over the year, most weeks at least are accounted for.

Opposite: **Orford Ness** 2012 gouache & pencil 24 x 35cm

Top: **Desert Pattern** 2011 watercolour, gouache & pencil 25 x 56cm

Above: **Day-book**

Angus McEwan

Through the years I've slowly but surely dedicated myself to watercolour. It wasn't a conscious decision initially, but I drifted towards using a quick, clean way of working which also allowed me to draw over the top if I needed to.

I enjoy travelling and it's been an important part of my work since I won the Alastair Salvesen Scholarship in 1996, which gave me the opportunity to travel and paint in China for three months. It was through this that my first real forays into watercolour began, mainly due to the logistics of carrying all my materials with me. My first attempts were frustrating and angst-ridden, but I quickly discovered how extremely versatile and forgiving watercolour could be. Travel continues to inspire me, mainly because I enjoy seeing new subject matter, and the quality of light, which is an important part of my work, is a lot stronger than I am used to.

In many ways I use travel to discover and record the past as it presents itself to me now: a moment before it is finally extinguished. I try to present a view of the neglected, a beauty that is inherently hidden by our attitude towards old, broken or discarded elements of bygone times. I want to give them value again.

At the outset I work from life. I work fast and hope to catch the essence of the subject before the sun moves. This often means I forsake accuracy in drawing to get an immediate impression of my subject. I may then work back in the studio or hotel room from memory, adding details and tidying up slack drawing. While I'm working, I take photographs at different times during the drawing, to give me an accurate description of the shadow movements through time. The painting is after all a summation of an experience through time. An interpretation of my subject is what I am after, rather than a reproduction. I often start a piece outside and finish it in the studio, using drawings and photographs as an *aide-mémoire*. I bring into the studio objects similar to those I am working on, to help me describe them more succinctly. The combination of all the elements

Far left: **Natural Selection** 2012 watercolour 71 x 103cm

Left: **Worn Out** 2011 watercolour 74.5 x 53.5cm

Right: **Top of the World** 2011 watercolour 76 x 29cm

working together helps to provide me with enough information to conclude the painting successfully. I try to avoid doing the same thing twice and often change methods or ways of working to avoid becoming stale.

Layering is exactly how I like to use watercolour. I call it optical mixing. Instead of producing black by mixing Raw Umber and Prussian Blue together, I apply a layer of Prussian Blue, allow it to dry, and then apply a layer of Umber on top. It produces a completely different result, the latter having a lot more depth to it than the former.

I've experimented with a lot of different ways to apply paint, especially when confronted by paper that has been over-zealously sized. In those circumstances, I have found that touching the surface removes about as much as you put down. That was when I started to spray paint on to my paintings using worn one-stroke brushes. I also 'print', using bits of cardboard to get an arbitrarily textured surface which can be broken up by spraying clean water through a plant spray. I believe I am part of a rare breed in that I paint my watercolours vertically. I can't stand a puddle on my work, so I rarely have my board flat as traditional watercolourists might.

I personally find watercolour a very forgiving medium. A lot of myths abound which help to persuade people that you can't make mistakes, correct, or alter your watercolour paintings, but that hasn't been my experience.

Colin Merrin

Having lived in London for most of my life I painted mostly urban subjects, however my recent paintings have centred on the South Downs landscape close to where I now live.

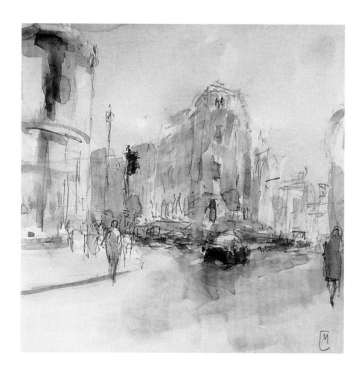

I use both acrylic and watercolour because I like their portability, immediacy and translucent quality. I often use paint without making any initial drawings or marks and enjoy the occasional unpredictability of dried blobs of colour. I use all possible techniques because I'm constantly looking for something new: each painting has to have an element of surprise. Working fairly quickly, I collect pencil drawings and watercolour images in sketchbooks when I'm outside and use them to inform oil paintings, however they are finished pieces in their own right.

Whatever I paint, the result is fundamentally about paint. In other words I use landscape as a vehicle to explore the medium and its possibilities, rather than the other way round. Having said that, there is a temptation to make the work completely abstract; nevertheless I try not to stray too far from the source material because I like the work to harmonise abstract and representational forms. This approach is of course true of many artists, but what's interesting is to constantly look for something new and fresh. I particularly enjoy using loose watercolour to suggest and imply, allowing the eye to connect with the imagination rather than making things obvious. 'Super realism' (I use

the term advisedly) is, when done well, clever and skilful. It fills space, but for me, leaves little or nothing to the imagination. The real skill and cleverness is about leaving space as something suggestive and ambiguous rather than explicit.

I use mostly artists' quality Winsor & Newton watercolour. I work with both round and flat brushes, though rarely sables these days as the synthetic brushes are perfectly good. I don't usually stretch my paper and I'm probably doing the work a disservice, but the speed with which I work necessitates my having many sheets of paper at hand to keep up the momentum and energy. I do mess up a few sheets before something good happens, but I never waste them; I save them and work over the top with

acrylics and oils. When I'm outside, sometimes the weather can add to the final outcome surprisingly well: a sudden downpour can make a positive contribution to a painting.

Most of my paintings are made in the studio from drawings and watercolours done *in situ*. Therefore the finished work is filtered from something directly observed into a more subjective and reflective piece of work. *En plein air* or in the studio, it really doesn't bother me how the painting develops, because it's not about recording place-specific images, but giving expression to what's seen. It doesn't matter whether a particular tree exists in a particular field; how the tree impacts visually within the composition is far more interesting. I may leave the tree out or add one,

Left: **St Martin's Lane** 2012 watercolour 20 x 20cm

Right: **Sketch 4** 2012 acrylic 15 x 15cm

Below right: **Sketch 5** 2012 acrylic 15 x 15cm

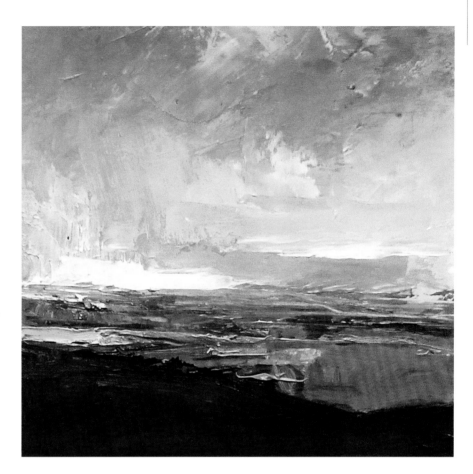

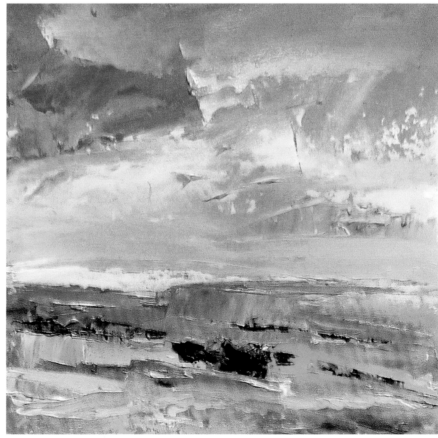

depending on what works. Painting does not record what's seen in any true or literal sense because it's a representation, and therefore a shift from reality or an aspect of it. That gives scope for invention and imagination, which is how we filter and process what we see. This process is unique to each artist and that's what I find most interesting.

I am profoundly inspired by Turner. His records of the landscape in rapidly made watercolours were more than just shorthand notations: they spoke volumes about what was to come. The Impressionists developed Turner's notions of suggested detail, reducing the image gradually towards a sense of abstraction. They understood how we perceive in terms of fleeting glimpses and visually half-formed images where our feelings, memories and sense of the familiar also play a more significant role. It was less about forensic scrutiny and more ephemeral in nature. Monet and Cézanne are for me the two giants of that period, but I have to acknowledge many more contemporary influences. David Bomberg, Edward Burra, Peter Lanyon, Joan Eardley and Felix Topolski are painters who have, for different reasons, inspired my work. I'm also drawn to current landscape artists such as David Tress, Barbara Rae and the Cornish painters Kurt Jackson and Neil Davies. Whether they work on a specific landscape or within the idea of landscape, they bring with their work a strong individualism and unashamed subjectivity; a sense of themselves and a passion for paint.

Michael Middleton

I went to art school in the late 1960s and early 1970s and so was exposed to the last gasp of 'High Modernism'. This meant navigating a path between Abstraction on the one hand and Pop Art on the other. Our bible was Artforum, which we eagerly devoured to find out what the latest trends were. The paintings one did had to be large to be taken seriously, and I vividly remember climbing a ladder to work on a 10ft-high work inspired in part by DeKooning. Although I am not tempted to work on such a large scale now, preferring small and intimate works, this period left me with an abiding interest in the more formal aspects of composition and an appreciation of American painters like Brice Marden and Frank Stella.

Since leaving art school and pursuing a career as a teacher, printmaker and painter, I have looked more closely at English and Italian artists, especially those who flourished up to and just after World War II such as Paul Nash and Giorgio Morandi. Paul Nash's landscapes in the 1930s and 1940s, when he was juggling with the competing influences of Surrealism and the native English landscape traditions, are particularly interesting. The juxtaposition of geometrical elements and more naturalistic landscape in the Tate's *Equivalents for the megaliths* is a good example of this. Giorgio Morandi is of course the quintessential printmakers' printmaker, but for me the importance of his work lies in the idea that the pursuit of the everyday and domestic can yield works of poetry, intensity and authority.

Ideas for paintings come from

Left top: **Quartier Jean Moulin** 2011 watercolour & acrylic 16 x 22cm

Left below: **Desirable Properties** 2012 watercolour & acrylic 23 x 23cm

Right: **Two Gardens Dedham** 2012 watercolour & acrylic 12 x 24cm

things I have seen and observed. I am interested in domestic architecture, gardens and landscape. I often work from photographs, exploring the images on a small scale in a sketchbook. Sometimes these 'studies' are taken to a high level of finish. Working from photographs has its advantages and disadvantages. You cannot approach your subject more closely by walking towards it or changing your viewpoint by walking around it: you are stuck with what is in front of you. Therein lies the challenge. What I attempt to do is 'interrogate' the photograph – to somehow get into it – to find out what lies behind that surface. It would be a poor work indeed if the photograph were more interesting than the painting.

I use simple materials like traditional papers and watercolours. I stretch the paper first and occasionally laminate a thinner, different coloured paper onto it. I work out the composition in pencil, blocking in the main component parts. I have experimented with acrylic and watercolour together and in that sense I am not a purist.

There is a close relationship with the work I do in printmaking and painting. Some works originated as ideas for prints and at other times the influence has gone the other way, with a print later becoming the subject for a watercolour.

Two gardens in Dedham · M·Middleton·'12

Bridget Moore

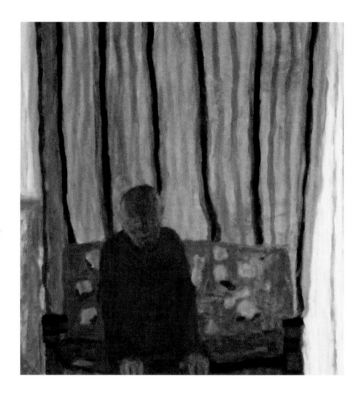

There used to be a black bungalow at the corner of Borstal Hill and Pier Point Road in Whitstable; my grandparents lived there. It sat in an orchard which my grandad had planted. They never owned the bungalow and when they both died it was pulled down, the orchard dug up and the land levelled. This occurred around about the time when I was leaving art school. As children, we never appreciated this 'haven'. It had no fridge, no heating, no TV. It had an air of musty fustiness, a 1930s feel and in the last few years had fallen into a state of disrepair – a sort of decayed opulence.

This atmosphere is what I have continued to find fascinating, and I have revisited and referenced it in many of my paintings. At one point memories of this were pin sharp, but with time they have faded and coalesced into images that are shorter on detail but stronger on an overall powerful feeling. It is a recurrent source of material. I don't really know how things pop into my mind but I'm grateful that they do.

At first, I found it quite daunting to work from memory. I'd been used to working from things directly in front of me, but, encouraged during my final year at art school, I began to experiment and to try and try again. I think working by this method has evolved into a way of looking. I often see something, however fleeting, and it sparks something – I'm able to 'clock' an image and use it as the germ from which things grow. It can be a difficult way to work as often there is no tangible material to go back to, but I always carry a small sketchbook to take notes and do drawings to work from. It can be pretty frustrating when the image I have or feeling or colour is just too obscure and too difficult to make a painting from, so a lot of ideas never come to fruition. But it can also be liberating and less restrictive: it can give more freedom to push images and colours and the composition around. Some of the best advice given to me at college was by Roderic Barrett, who said to make sure a painting did 'the dance', your eye must be given the freedom to travel over the painting and not be fixed too much to just one thing. It gives a painting its own rhythm. I am drawn to strong imagery, I love the seedy quality of circuses and theatres, the inside dusty light that comes on a hot and sunny afternoon with the curtains drawn.

When I get an idea for a painting it is rooted in something I have observed at some point, but can start as an abstract notion that develops, and I just run with it in my head and see where it goes. I write it down before I forget. If I keep it too long going around and around it can get stale. I have lists of 'to do' paintings. As long as I've written them down, I can come back to them even years later. Over time a memory gets dulled, but once you start remembering things they expand, you remember the light, the sun, the colour more. I think the thing I'm trying to paint and give a painting is atmosphere.

Left: **Mr Weller** 2009 gouache 27 x 25cm

Right: **Bareback Rider** 2012 gouache 16 x 22cm

Below: **Couple at Innisfree** (detail) 2009 gouache
16 x 23.5cm

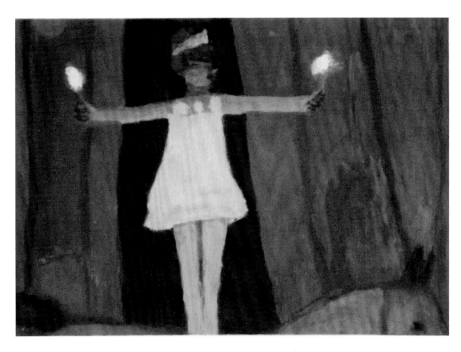

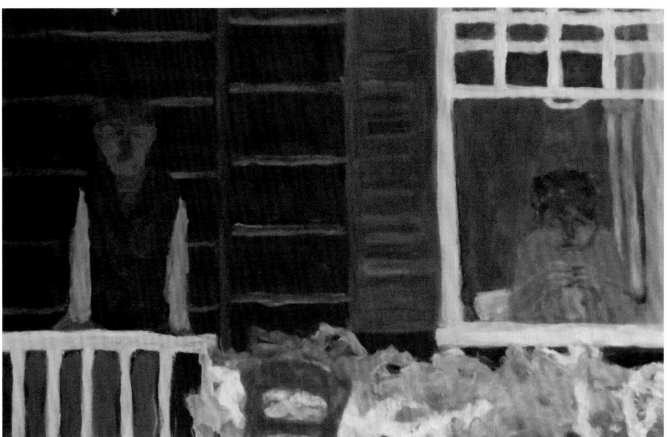

Peter Morrell

I have been a member of the RWS for a long time, during which many changes have taken place. Not only has our gallery changed location but also a big change of attitude towards watercolour has occurred generally. Within the RWS we have extended the idea of what is considered to be watercolour, and now include work in acrylic and other water-based media. The divide between classical watercolour painting and abstract work has grown wider and the size of paintings has grown also. I don't write this as criticism as the work is always of the highest quality.

During the period many changes have gone on within me also: my working priorities, ideas, intention and capabilities, and not least my own health.

Drawing is basic to all my work. In watercolour I have drawn directly in colour. I do no under-drawing, preferring to lose myself in what watercolour does best. As my interest in landscape is certain atmospheric conditions, it is well suited to the fluidity of the water-borne medium. I work rapidly, on a smallish scale, in order to capture the fleeting effects of cloud, light and mood. Sometimes I use a wet approach, sometimes dry, according to the demands of the subject. I have no fixed method or techniques, so I often break rules. I don't worry over what brushes to use, sometimes even giving the work a good scrub. I use good quality rough, or not pressed, paper and I like a tough surface that can take the knocks. I use tube colours on a tin plate as a palette.

My gods in watercolour are Girtin, Turner, Cotman and Cox, so yes, my methods are traditional and I suppose unashamedly classical. All that is fine and my watercolour working priorities remain as they were, but doing watercolours at all is a bit 'what was'.

In the last ten years or so I have been working with gouache, an opaque and tractable medium. This is a compromise because I can no longer do the watercolour I would like to do. Not for want of trying, either. I have had problems with my eyes over the last fifteen years or so and consequently have had many operations on both eyes. The first to go was actually retrieved so is now more or less normal. The other, my left, is now blind. To do work in proper watercolour it is necessary to have a delicate contact with the paper and the paint. I have no depth perception, to that degree, of the distance at working range. The painting process becomes so slowed by being 'careful' that all spontaneity gets lost. Oil painting is not so much a problem, bigger for a start and one moves about while doing it. There is still the difficulty in colour mixing, picking up too much or too little on the palette knife, and sometimes picking up the wrong colour.

I am still working on my oil painting every day and have a great need to keep up my drawing and still draw from the model, in spite of my painting being concerned with abstract/formal questions.

Watercolour is always complementary to oil painting for me and I would like to do it all, abstract and observational.

Right: **Dark Cloud over Dartmoor** *c.*1978 watercolour
26 x 30.5cm

Below: **Mountains of Scotland** 1981 watercolour
28 x 10cm

Alison C. Musker

Venice – in the spring there is a constant chirruping of birds in the gardens there.

Lying in shade, the water is pale blue, its walls in ochre colours, and moss green by the watermarks over the old brickwork. Those bridges are of marble, spanning the canals of deep green, of pale marble, across the Grand Canal.

We looked out onto it: the vaporetto, laden with trugs, whose sides were filled with flowers. The motors revving up on the boxes of fruit and vegetables, the sounds of church bells. The light in St Mark's Square was startling, just trickling onto the column sides, and showing over the statues and tracery. Embroidered in marble and embellished with it in such detail, it stands firm in its glory.

The four horses looked down from their pedestal. Golden mosaic, half-circles, the mineral mosaics. What history has taken the stage for so many years and generations. A theatre of people in the main square. At Florian's, upheld with special glass from Burano. The music outside rising and falling, as bejewelled accompaniment, quite magical.

When the darkness begins to come down, turning dark hues, anthracite shadows lean over the canals. Intriguing with the narrow alleyways, whispering secrets. Dissolving colours that float down the Grand Canal.

Another day, hearing the bustle of morning heaving from the Palace

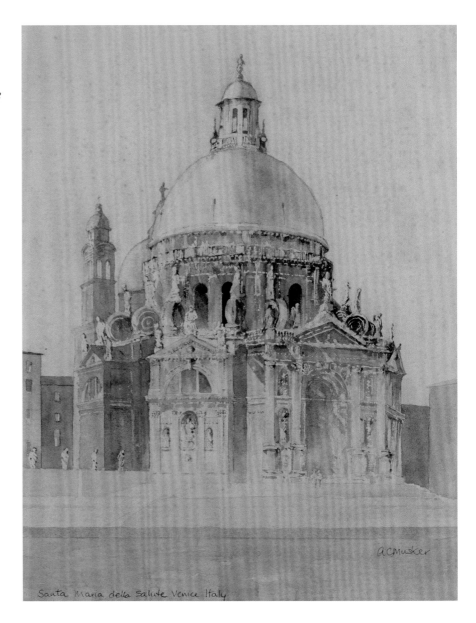

Santa Maria della Salute Venice Italy

of Gazpari, I heard the gondoliers rowing their boats, down Santa Maria della Salute, Palazzo Bararigo, next to Palazzo Dario; and then from San Giorgio Maggiore, view of the Grand Canal, and Ca d'Oro, and Frari Basilica, large and imposing.

Tintoretto reigned supreme, his monumental works, covering the Scuola Grande in San Rocco. San Giorgio Maggiore Doge's Palace, like a cake with perfect pink and white icing, pinnacles round the edge, looking majestic against the strong blue of the sky.

Five domes set out in a Greek cross; the architect was ordered to build a chapel, the finest ever seen. In the changing light, transformed with evanescent hues.

These are the images that have inspired me.

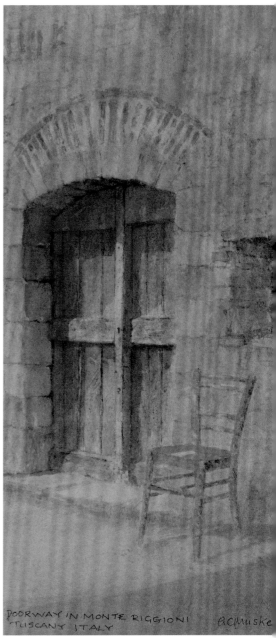

Left: **Santa Maria della Salute, Venice, Italy** 1985
watercolour 50 x 61cm

Above left: **The Chapel at Eton College** 1989
watercolour 46 x 45cm

Above right: **Doorway in Monterrioni, Tuscany, Italy**
1980 watercolour 56 x 75cm

John Newberry

I dislike watercolour painting in general. The medium is too easy; it encourages finicky detail and overworking. But it has the advantage of speed, is quick to apply, quick to dry and the equipment is portable. It is ideal for work out of doors and on special trips.

Of course, speed can mean mistakes, but it gives no time for second thoughts, for questioning design, for changes. The best stimulus is the pressure that comes from having to make decisions and I find this the way to ensure a fresh vibrant and, hopefully, breathtaking picture. But speed and direct observation raise problems with all the things which change during the two or three hours of work.

First, the sky is the most obvious. I try to use what is there when I choose the subject, so ideally the clouds go in first. But they can change, even during the drawing, and I often wait until an exciting sky turns up and bang it down halfway through or even at the end.

Secondly, cast shadows must be convincing. I prefer sunlit scenes, but shadows race across the picture as the sun moves. I usually put all of them in at once and just hope that they will survive and look correct at the end. In fact as a general rule I put down darker tones first and progress to the lightest.

Thirdly, figures, especially in townscapes, are essential. Empty streets look unreal. People give the scale of buildings, and by their size help to establish foreground and distances. But they always move. How lifelike they can be when done in a hurry is always a question, but it helps to place some near figures early on. If left too late their colours can never be bright enough.

These pictures of the centre of Chester give good examples of these problems. All were completed over five days; the whole package had to be finished by the last afternoon. The one of Bridge Street is the calmest and was started first. But where I was sitting, lorries, refuse carts and delivery vans invaded the foreground every morning and made things impossible until Sunday. Streets are like theatre. The scenery is provided by historic buildings, actors are the crows of tourists, street cleaners and the town crier. They all get in the way of the bit that you are trying to look at. They ask questions. I do not mind being watched, but cannot paint and give a sensible answer at the same time.

Also there is background noise, music from hymn singers, buskers and shops. Fortunately there were no parked cars; the area around the Cross is for pedestrians. Cars normally form a complete obstacle to working on the spot in towns.

To cope with this chaos I either finish off one painting without a break, or have several on the go from different places at various stages. One will be from eight-thirty to ten on a sunny morning. After a coffee I move to another from ten-thirty to one o'clock, overcast. There must always be an escape, a place indoors or under cover in case of rain.

Sitting on the ground gives me a low view and I start by establishing my eye level, a line right across the paper. This is especially needed here in Chester because all the roads at the Cross slope up or down. The shopfront perspectives go to one vanishing point but the sloping road itself goes to another – below eye level for a downward slope, above eye level if one is looking uphill.

Then I confirm my centre of vision, the spot at which I am looking, so that the perspective remains consistent. I place the edges of what I want to include, left and right, top and bottom, all according to the proportions of the paper. After these steps the architecture almost draws itself.

The final pressure comes from exhaustion. If I cannot find the strength to do any more then I call the picture done – no alterations in the studio afterwards.

Paul Newland

Making choices of what is representative from one's work can be difficult. I treat a number of different subjects – interiors, still-lifes, landscapes both urban and pastoral. These three images I picked out from the available photographs because of certain connections between them. They were completed at more or less the same time, about six years ago.

Bonfire in SW8 is a big (for me, anyway, at A1 or larger) watercolour. It is the third of four versions of this view, all with different areas of focus and different light. The geometry, but also the mutability and the atmosphere of the place were what motivated me, I think. The allotments are situated on high ground overlooking Lavender Hill and constitute an extremely private kind of place. I visited frequently when I lived a short distance away, in Camberwell, and made very many small drawings and watercolours over a period of some years. This composition is painted on a rough cream Khadi paper which you can see still, in some places. It was not wisely chosen because it was hardly sized at all, I should think, and was very absorbent. However, once started, the thing got a momentum of its own and I continued. It is, really, a work in progress since it is not yet, in my view, resolved.

Allotment Study (A4 approx.) is wash and pencil as you see in the foreground and left-hand side. But a wind blew up, and some terrific clouds, so I applied gouache from the tube and manipulated it with fingers or brush. The light areas at front and extreme left are untouched paper. The studies I make are more spontaneous and graspable, perhaps, than the larger pictures. No bonfire was burning on this day.

Of the many studies, some are made before I begin a large work, some

during its progress. There are usually a lot of pencil drawings too. All are around me on boards or on the wall or tables, when I am developing an idea.

Zinc Leaves and Holographic Paper is one of many still-lifes I made a few years back, sometimes much larger, sometimes even smaller. With this, and others, I worked directly from the things on tables in front of me. The pictures were inclined to change their appearance a lot in the course of work. The *memento mori* theme of

many old Dutch and Spanish still-lifes was in my mind. The metal leaves came from an elaborate Italian funerary wreath, which was clearly less permanent than its originators intended, since it and many others had become unfashionable enough to be cast upon a rubbish heap behind the wall of a small cemetery in Umbria. The tiny skull (creature unknown) and the Chinese tin toy (quite an historic object, these days) had an anonymous memorial quality. The sparkling lights

from the paper in the background seemed suspended, not resting *exactly* anywhere in the space.

Left, top: **Allotment Study** 2006 watercolour & gouache 20 x 27cm

Left: **Zinc Leaves and Holographic Paper** 2008 watercolour 16 x 30cm

Above: **Bonfire in SW8** 2007 watercolour 61 x 82cm

Barry Owen Jones

Seascape, landscape, architecture and the light affecting them inspire and give variety to a subject. Travel to unfamiliar places provides visual excitement and stimulus. Sometimes the image creates its own composition; at other times mist, fog or a storm provides the inspiration, as do contre-jour *situations.*

Drawing is all about looking – getting to know your subject intimately before beginning to paint can only help to keep the work fresh and alive. A detailed study in a sketchbook allows me freedom to develop a picture in size and feeling. I enjoy drawing, especially on watercolour paper.

I usually choose to work on Saunders 140lb paper NOT or rough surface depending on the detail that I require, stretched so that it will always stay flat. I do not like carrying a lot of gear around, so use 5mm marine ply with ¼ imperial paper stretched on it with brown gummed tape around the edge, laying the soaked paper on the board and allowing it to dry flat. The paper will now take reasonably rough treatment.

My watercolour box is a traditional black japanned type from Winsor & Newton, filled with half pans which I refill with colour from tubes when required. My palette is selected from the following: Cadmium Yellow pale, Cadmium Yellow, Cadmium Yellow deep, Bright Red, Venetian Red, Madder Brown, Rose Madder, Hookers Green, Payne's Grey, Lamp Black, Raw Sienna, Raw Umber, Burnt Umber, Vermilion, Vandyke Brown, Cerulean Blue, Windsor Blue, Ultramarine, Cobalt Blue and most importantly of all – white paper!

I use a range of brush sizes from 8, 6, 4 finest sables. These are important as sables will hold a good point and offer perfect control, allowing me to pick colour off the paper as well as apply it. I also have a large sable and ox-hair brush and several sizes of flat-end brushes. A selection of small sponges can be useful. One collects a variety of tools over time. I occasionally use masking fluid, but it needs experimenting with. It is useful for painting light things against dark backgrounds but beware – it wrecks decent brushes!

I like to build up my paintings with light washes initially, sometimes under-painting with another colour, especially on very dark areas where applying a dark colour all at once can give a dead look to the piece. I let these washes dry before applying more paint or the colour will lift off and the area will be irrevocably ruined. One tends to regard watercolour as a quick medium; unfortunately this is not always the case – working in the studio on a large painting can be very time-consuming. A useful technique is scraping out. Turner used this to good effect in many ways. I once scraped the whole lower half of a sea painting using a rough paper and taking the top surfaces off the paper with a razor blade to indicate the highlights in the foreground of a yacht race.

Body colour in the form of white gouaches is also useful if used with care – one does not have to be a watercolour purist. The aim should be to say what you feel about the subject – how this is achieved is of secondary importance.

When you think you have said all you can about the subject then the work is finished. Resist the temptation to fiddle. Put the painting in a mount and leave it alone – good luck!

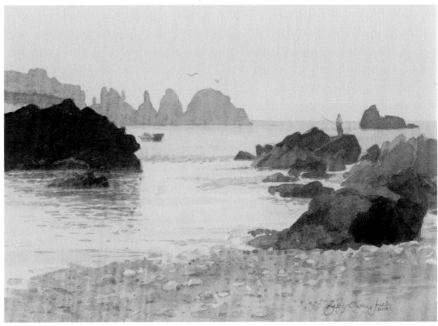

Left: **Fishmarket Interior, Venice** 2006 watercolour 30 x 21cm

Above: **Daybreak, La Rochelle** 2010 watercolour 30 x 22cm

Right: **Winter Fishing, Moulin Huet, Guernsey** 2011 watercolour 30 x 21cm

David Paskett

There is a complexity in many of my studio paintings, resolved through a gradual process of balancing and ordering, bringing out patterns of echoing rhythms, giving emphasis to shapes, tones or themes in the way that a conductor might direct an orchestra. In nailing down the subtleties of observed tone and colour, nurturing the differences of greys, I employ both transparent and opaque techniques.

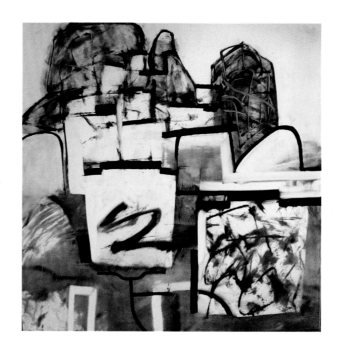

An oil painting method of thin underpainting with 'tonking' [a blotting technique] and scraping back between subsequent layers has influenced the way I use watercolour. Egg tempera introduced me to ways, used in the Italian Renaissance, of creating networks of small brush marks as an alternative to wash overlays. Gouache paints have been a constant but watercolours were a mid-career move for convenience sake on becoming an itinerant painter. I often start a watercolour with the conventional sequence of Cobalt Blue tonal underpainting overlaid with washes of Yellow Ochre and warmer colours, followed up by a lengthy process of adjustment, enriching and clarifying with deeper hues.

An intuitive geometry underpins all my compositions. Edges are defined and shapes 'lock' together with a clarity possibly rooted in long sessions cutting and leading up stained-glass windows in college days.

The paths that shadows take, the dynamic patterns they make – these lend gravity and theatricality to a setting. In clear sunlight, dramatic shadows assuming the sculptural, sheet-metal solidity of an Anthony Caro sculpture, can imbue the otherwise un-noteworthy with a significance that will stop me in my tracks. There is a complicated story behind the arrival of disparate things or people in particular locations, and it is their juxtaposition as much as their identity that gives them intrigue.

As an outsider, travelling in foreign parts, one's sensitivity to fresh and exotic juxtapositions becomes heightened. An enticing new light illuminates everything. On arriving somewhere new, especially in China, I head for the markets, bridges, watersides, eating places and the surrounding backstreets – locations where people meet and trade. Then for some peaceful painting *en plein air*, settled in a quiet backwater.

The crowded, the unsymmetrical, the disorganised have an emotional appeal and tell a story. Unfortunately modernisation has tended to encase, cover up, re-house, disguise, privatise, clean up and take the human edge off reality.

For some things it is practical to paint on location, for others I take photographs, though they are a poor substitute, and paint in the comfort of the studio. However, a sense of 'being there' is vital for me in the finished painting even if sourced from photos. A large body of my paintings of China, when seen together, tell a story and creates a bigger picture and may even have anthropological as well as aesthetic value.

In parallel to figurative painting my maps like 'placescapes' are a way of distilling a mass of memories into one multi-faceted image. These more abstract and playful inventions, employing mixed media, collage and Chinese ink, feed back into my figurative work, opening up fresh possibilities in the search for new subjects.

Left: **From Anhui to Guilin** 2010 watercolour
75 x 75cm

Right: **Glistening Waters** 2010 watercolour
57 x 37cm

Below: **Chair Partnership** 2006 watercolour
69 x 47cm

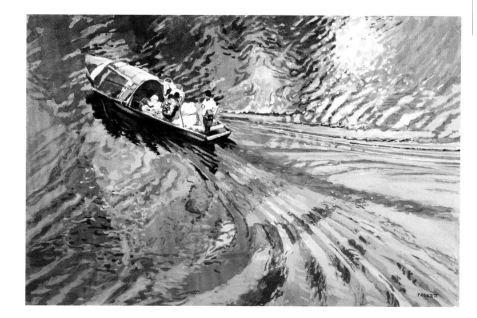

Observational drawing is a part of daily life. My quick line work, in contrast to my hard-won paintings, often suggests rather than defines, the eye and the hand catching first what the brain later recognises. In cafés and public places, tracing interactions between heads and hands in conversation, along with the accompanying paraphernalia of cups, phones, computers, books or cutlery. When drawing I am constantly intrigued by those 'Chardinesque' invisible lines of communication that travel through space.

David Payne

The magic of watercolour resides in its lightness, fluidity and translucent washes and its subtle, luminous colours. Once an adjunct to drawing, it is now an art form in its own right. The material requirements of watercolour painting are, by comparison with other media, simple. This may go some way towards its popularity with the experienced painter and the novice beginner. However popular it may be, the easy flow of water on the palette is not echoed in the easy production of fine paintings.

To paint well in watercolour is difficult; it calls for a disciplined and planned approach, and above all, a sensitivity towards the medium itself. Watercolour is capricious; one is never in complete control, but this is part of its attraction: it has the ability to surprise.

Some painters like to work in the 'Turner tradition'. Broad overall washes establish tonal areas. There is also a technique called 'wet on wet' – paper is soaked and at a chosen time work begins. Such paintings can be atmospheric in quality. In the dry method, blocks of colour are laid next to each other, sometimes overlaid with washes to bind them together. Landscapes do not always have to start with the sky. In *Castlerigg Stone Circle* the trees behind the stones were blocked in first.

My method of working is traditional. I visit places that have a special interest for me. Working in pencil and watercolour, I make sketches, sometimes producing a *plein air* painting. I also make a photographic record. The use of the camera is much debated, but for me, it is an aid to memory, not something to make copies from. Mostly I paint on papers made by Saunders Waterford, Arches and Fabriano. Generally I work on the fine-grained surface – these papers are referred to as NOT or HP (hot-pressed). My smaller pieces are painted on 140lb NOT or HP watercolour blocks. Unlike sketchbooks, the paper is fixed around the edges, no stretching is required. For larger paintings I like to work on sheets of 300lb weight. Heavier papers should not need stretching. Stretching watercolour paper is another area of mixed opinions. I rarely stretch paper because I like to paint directly onto the pristine dry surface. When I do need to stretch paper I wet only the back surface – using this method I have on occasions stretched fully completed paintings. My colour palette I would again describe as traditional. I have a collection of tube colours and paint boxes, but I invariably return to one I have used from the start of my interest in watercolour. It is an old metal box with enamelled mixing surfaces. I have it filled with half- and full-pan colours. My preference for various colours varies, but I generally use most if not all of the earth colours.

The development of a painter's work involves many factors. Personality and past experience are formative in this process. My paintings combine imagination and observation. Places made significant by history or association are often featured in landscape settings (see *Thomas Hardy's Eggardon*). The paintings acknowledge a strong literary element, and in this respect follow the manner of William Blake, Samuel Palmer and Stanley Spencer – painters I have admired since my student days. They belong to an English tradition, in which a heightened reality is present with an undercurrent of surrealism. In my still-life paintings I like to explore the

elements of design together with the emotive power of the figurative image (see *Rupert Brooke*). Overall I do not think we choose 'how to paint' – the choice is made for us! One Royal Academy reviewer referring to my painting, *The Last Gleaner*, wrote, 'A small painting I would dearly love to possess, small and intense and again strange and distant'. I believe this sums up much of my work.

Left: **Thomas Hardy's Eggarton** 2012 watercolour 31.5 x 43cm

Above: **Castlerigg Stone Circle** 2011 watercolour 35.5 x 50.5cm

Right: **Rupert Brooke** 2010 watercolour 28 x 38cm

Simon Pierse

Watercolour is a medium that works well when applied in layers, so that one colour is visible through another. A while ago I became interested in the idea that watercolour could work as a sort of visual metaphor for memories – which, when I try to picture them in my head, seem translucent and shifting. This led me to start experimenting with watercolour in conjunction with tissue paper, and subsequently with transfer and collage.

Old photographs became another important element – a different kind of visual memory. We probably all have a biscuit tin full of old photographs: faded colour, black and white, deckle-edged or passport sized, that are key to our family history and our sense of who we are.

I started using a technique of transferring colour-photocopied images of old photographs to watercolour paper using cellulose thinners (the photographs had to be photocopied in reverse first for the image to come out the right way on the painting). Then I discovered a material called Lazertran that enables you to overlay a translucent image directly onto watercolour paper (it works a bit like those old-fashioned bicycle transfers). Often in a painting I combine all three of these transfer techniques, both under and over layers of watercolour. Stamps, train tickets, writing (both real and imagined) were introduced too, both

as little tokens of remembrance and because letters are (or soon become) memories made out of paper.

A lot of the paintings that I made in this way are quite personal to me and took a long time to complete. I'd often work on several at a time, tearing off or adding fragments, and quite often they would sit in my studio drawer for months – or even years – before I returned to them to add more layers of collage or paint.

Left: **Planter's Club** (detail) 2004–10 watercolour,
collage & mixed media 23 x 67cm

Below: **Tea from Darjeeling I** 2003–4 watercolour,
collage & mixed media 28 x 42cm

Bottom: **Tea from Darjeeling II** 2003 watercolour,
collage & mixed media 40.5 x 480cm

Richard Pikesley

Although I have on occasions painted some large watercolours, I most enjoy the way the medium allows me to get a lot down in a small space. Painting in oils always has to be a planned process, the kit is rather bulky and messy and challenging to cart about, whereas with watercolour so little is needed. This means that whereas oil paints demand planning and forethought, I can have my minimal watercolour kit with me just in case something turns up.

This means that for me, the beginnings of a new thread in my painting are often marked out by watercolour and then subsequently developed in watercolour or other media. In practice this means having my most minimal kit with me when I'm doing other things, and in this way painting can spring out of life's little surprises rather than necessarily being planned in advance.

My most basic kit is a cigar box, small enough to slip into a poacher's pocket inside my jacket. Its lid, with the addition of a little bulldog clip, becomes a drawing board, a few sheets of hot-pressed paper, cut to size and protected in a plastic bag and the smallest watercolour box of half pans, a little water bottle and a couple of brushes, a pencil and sharpener will all fit inside. The hot-pressed paper with its hard surface allows me to make small detailed marks or write pencil notes as well as working quite broadly in washes. I like the way the wash floats across the smooth paper before it collapses into its surface, the feeling of touch through the brush is quite different to the more usual NOT or rough papers.

A typical encounter happened quite recently after I'd had too many days in the studio. The combination of poor summer weather and large paintings to finish had left me feeling that I needed some time away, and a few hours' fishing seemed like a good way of stepping back from knotty problems of composition so that I could return with my eye refreshed. The approach to my chosen bit of river necessitated crossing a little side stream and with a bit of colour in the water and the river still high from all the rain I went looking for a safe crossing point – no point in getting my waders full of river this early in the day. So pushing gently through the nettles I looked for a shallow spot further upstream. The morning was warm and sunny and the sheep were under the trees by the brook. On being disturbed they stood and looked at me for a bit before settling back down in the shade: too good a subject to miss. I spent most of my day making drawings and little watercolours. Working on a small scale I could make lots of starts, laying each to dry on the ground

beside me while I began another, returning to each in turn if there was more to be said. These little paintings can be quite intuitive, allowing me to freely explore a number of ways of composing or cropping a subject. The act of drawing helps to fix the core of an idea in my head. I returned several times over the next few days to make a series of paintings.

At other times, when I've been working from a single viewpoint but have wanted to spend a day gathering information, I have worked on a single large sheet of paper on which I have made a number of little studies of different aspects of the same subject, or recorded how my view has changed over several hours or a whole day. With a large sheet of paper stretched on a board I'm free to hop from one study to another, often alternating between two or three as the paper dries so that I can work continuously, without having to stop and wait. This was the case with the large sheet of studies I made at St Ives during the making of a film for the RWS.

Left: **One Sheet of Paper, St Ives Head**, 2009
watercolour 56 x 76cm

Right: **Two Jacobs** 2012 watercolour 12 x 15cm

Below: **Crossing the Brook, Winsham** 2012
watercolour 12 x 15cm

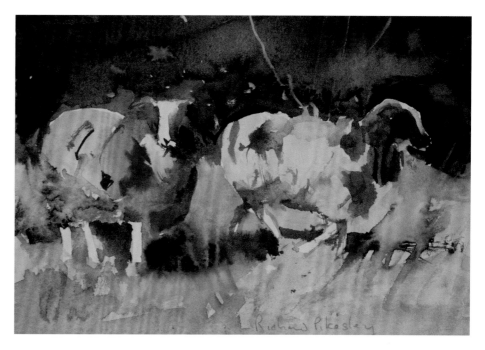

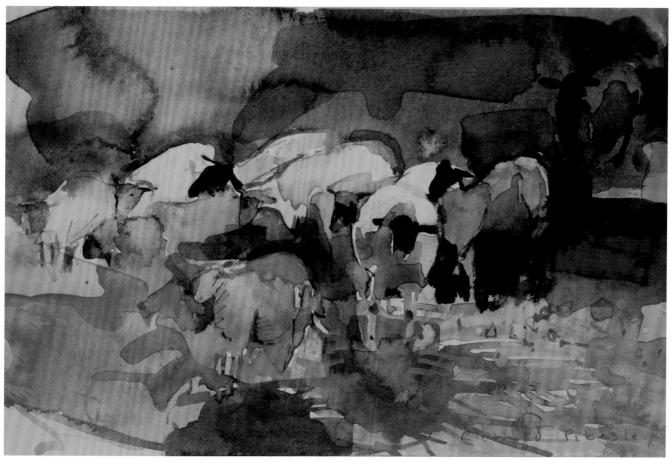

Geoffrey Pimlott

After many years of gradually abstracting the seen world, I decided to abandon this process and create visual compositions that engage and entertain the visual sense of the spectator through arbitrary compositional arrangements of geometric shapes with no such external reference.

The initial images emerge from sketches that are usually quite small, often drawn in gel pen, indicating considered design within the compositional structure through shape and tonal colour balance. The design for the painting is drawn out very precisely, using geometric instruments, adjusting compositional balance and design as necessary, from the small sketches, before colour is applied. Usually, a small group of colours is selected to work with; this gives intense control over the composing of visual rhythms within the work. I rarely make colour studies for a final work, but develop the compositional rhythms and balance, working directly on the surface, with one colour and tone at a time, positioning each at various points within the composition. The initial structure is extremely flat and design conscious. From this point the painting will develop visual intensity through the introduction of texture and mark, giving what one might call mood and atmosphere to the work.

I have studied, and practised, most techniques from eighteenth- and nineteenth-century watercolourists' treatises, and feel I am able to develop my own working processes because of

this knowledge. I wash, glaze, brush, dab, daub, tonk, scrape, scratch, scumble, drag, drip, spray, overlay, stamp and press raw and mixed watercolour and other water-based media onto prepared papers, revisiting and revising what is going on until the composition unifies and is complete.

I often coat watercolour paper with rabbit-skin glue to make a more malleable working surface that I can rework as necessary, in creating the visual harmonies that gradually pull the composition together. I prefer rough papers because my process is quite vigorous and I like the textural effects these papers give, but I also use a NOT surface at times. Fabriano, Arches, and Saunders papers are my main choices. My preferred watercolour paints include Da Vinci (Californian), Shin Han (Korean), and Lucas (German). I use Lemon and Indian yellows, Vermilion and Alizarin Crimson reds, Cobalt and Cerulean blues, Viridian and Emerald greens, Raw and Burnt Umbers, together with Black, and Chinese White, with other more obscure colours as required, to create transparent, semi-transparent, and opaque paints to be placed next to, and laid over, each other. My paintings are not necessarily uniform in shape as I am aiming to create a visual composition, so will, at times, only develop selected areas in paint, leaving others unworked.

My historical reference includes medieval illuminated manuscripts, early Italian Renaissance paintings and works by Pieter Brueghel the Elder and Henri Matisse, because of their awareness of the necessity of design within painting. I also continuously compare my work with what is being produced by other artists; judging my standards against theirs.

Left: **On a Day in May** 2012 watercolour & graphite 46 x 70cm

Above: **Green Chevrons with Red Triangles** 2012 watercolour & pencil 42 x 45.5cm

Neil Pittaway

My strong visual imagination enables me to create ideas and imaginary worlds and to shape and control information from many different sources including travel, historical materials, photography and direct observation. I create rich tapestries of images and patterns within the main compositions; often these are inspired by different cultural traditions, most recently creating fusions of eastern and western traditions from travels to the Everest region of Nepal.

This is evident in *A Passage to Ama Dablam*, where I have used the essence of Nepalese *tanka* painting with traditional western, almost realist, directly observed painting styles and techniques, creating a patchwork of cameo scenes of the Nepalese Himalayan landscape.

In other work I base my paintings on sketches I have produced on the spot. This seemingly straightforward approach to painting produces another kind of result that gives the subject an enigmatic quality. For example, to create *Looking toward Ama Dablam*, I transported myself back in time to the moment I first saw the mountain, trying then to recapture that first glimpse, through re-living the emotional and visual experience. Memory and meaning become very important when painting a subject, trying to re-create with pigment and water the essence and the magnitude of the place.

Travel has been one of the main influences for all my work. Everywhere I go, I sketch from direct observation in Italian leather-bound sketchbooks, making a permanent record of

ideas and places visited – my own simulation of the Grand Tour. I believe passionately in observing the world closely. I undertake extensive research alongside the directly observed work, then channel and shape this to develop my own ideas and concepts. I follow aspects of Impressionist tradition, creating works that try to capture the direct essence of a place, but I also use symbolism in my work, combining imaginative historical ideas and concepts with direct observation.

I work mainly on paper because I like its tactile elemental qualities. I like the way paper can feel textural when watercolour or pen and ink have been applied, or how certain paper has slight imperfections or deckled edges and watermarks. I do not stretch my paper as I like the paper to form its own character naturally: the curves and bumps, if they happen, add to the tactile surface and enhance the paper's distinctive properties. I have used many papers including Arches, Two Rivers, Saunders Waterford and the specially produced RWS paper, but although I still frequently use these I have recently discovered the handmade Italian

Amalfi paper, which I have used to create my recent paintings of Nepal. The Amalfi paper is particularly suited to creating landscapes of mountains as well as pen and ink drawing, because of its smooth, cloth-like surface, which is very absorbent; its versatile qualities suit many of my approaches to watercolour painting.

When using watercolour I find it important to be bold and not afraid. I particularly like the directness one can achieve with watercolour and I try to exploit its translucent qualities by using a great amount of pigment with large quantities of clean water to produce a stained-glass quality on paper. I soak the paper at the start, or even during the painting process if the pigment has become too dominant, then let it partially dry before working or reworking the surface. I often just lightly map the composition out in pale tones of watercolour, as I find pencil can be too heavy. Titanium White is good for adding line and extra body surface to the picture. When a painting is dry I sometimes add washes of colour lightly over its surface to create a more complex luminous effect.

Left: **Ama Dablam, The Sacred Mountain** 2012 watercolour 40 x 30cm

Above: **A Passage to Ama Dablam, Nepal** 2012 watercolour & acrylic 82 x 123cm

Right: **The Gateway to Everest** 2012 watercolour & acrylic 82 x 123cm

Thomas Plunkett

Watercolour holds many secrets. The elusiveness and the very accessibility of the medium is why it holds the attention of so many artists and collectors. The combination of water and pigment holds myriad opportunities for being creative and for pushing boundaries. For me, one secret of watercolour painting is to use the medium intuitively. In breaking the rules, and if that rule-breaking works, you have created your own new rule for watercolour painting.

When I am painting I try to experiment. I like to engage with the process of making and see what transpires. I enjoy the process of pushing the medium and myself. When a painting feels right, that is how I know it is finished. I have got past the problem of missing that magic point when a work is finished and then overworking it, losing the hard-won spontaneity of the painting. Knowing when a painting is finished and when to stop is something of a secret, and one that takes time to learn. This is different for everyone engaged in the challenge of painting in watercolour. Experience over time has taught me that stopping sooner rather than later is the best idea. My advice is that you shouldn't be afraid to leave something for the viewer's imagination to complete.

Above: **Venetian Market** 2012 watercolour 20 x 29cm

Right, top: **Palazzo, Venice** 2012 watercolour 20 x 30cm

Right: **Diamond Jubilee Pageant from the Terrace of the House of Commons** 2012 watercolour 74 x 36cm

I am constantly pulled between the freedom of abstraction and the more direct communication of figurative work. The directness of representation can sometimes be refreshing. I very often work using just the blank white of the paper and my imagination as a starting point for a painting and build the work from a series of marks, taking shape, bit by bit, placing tones, colours and shapes until something is achieved.

Possibly the biggest secret I will share on watercolour is the water I use. My secret is that I don't change the water I use to clean my brushes quite as often as I should. This can create some great washes of greys and browns with which I can build up elements of a painting.

The speed and immediacy of watercolour as a painting medium, and the way you can work quickly and freely using wet-on-wet techniques and then later achieve great control in the same painting when things have dried a little, holds a fascination. It is the accidental in watercolour, or the strived-for yet unplanned successes, when the pigment dries in a particular way, that keep me working in watercolour.

Over time I have learnt not to overwork paintings to deaden the impact of a gestural mark, or clean up too many of the happy accidents, but leave works with something left for the viewer to interpret.

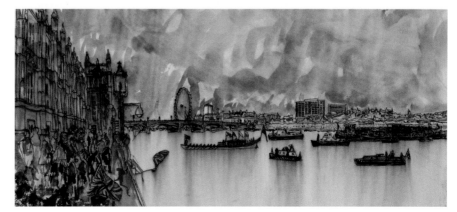

Saliann Putman

'It is not my intention to paint life but to give life to painting.' Pierre Bonnard

I am on a journey and I know that I will never arrive, but it is the journey that is important to me. I cannot accept where I am; I am compelled to move on – to search for what I know is just beyond my reach.

I paint because I have to – it is a means of communication, of telling the world what is important to me. Memory and imagination play a big part as I strive to interpret my emotions in paint. I am an intuitive painter, not an intellectual one. It was Cecil Collins who said, 'Allowing the intellect to dominate produces "dead" art'. My paintings come from deep feelings and a love of the materials that I am using.

If I had to choose two painters who have been the greatest inspiration to me they would be Pierre Bonnard and Mark Rothko. It was wonderful to discover that Rothko had been greatly inspired by Bonnard, and had created a number of his 'multiforms' in response to seeing the Frenchman's paintings in New York in January 1947, the very month in which Bonnard died. I have always admired those painters who have walked the tightrope between figuration and abstraction: Nicolas de Stael, Richard Diebenkorn and William Scott.

When Abstract Expressionism appeared in London in the late 1950s it was a revelation. The raw materials of painting are paint and the two-dimensional surface, and here was Rothko demonstrating that that

was enough. It seemed to me that this was the truth – no longer was it necessary to create an illusionary three-dimensional space to depict 'reality'. From this time I realised that my interest lay in the abstract qualities of painting: colour, mark and space. The picture plane no longer had to reproduce an object, it could be an area to act on – it could manifest the artist's presence. Subject matter has never been important to me. However, I continue to be attracted to that area between figuration and abstraction. I am always aware that a painting can represent an emotion just as it can represent a flower.

During recent years I have been making paintings that are built up in layers, a palimpsest of marks that obscure and reveal the history of the making of the work. The inspiration for these works came from a visit to the medieval city of Perugia in Italy,

where billboards, ripped and worn and layered with more posters and graffiti, had for me a beauty that competed with the ancient surfaces of the buildings. I always seek an energy in my work and the scrawled and sprayed script had an inspiring quality. But it has always been an ambition to work towards a greater simplicity, and this is where I am at present. I work in series, the images always developing at the same time. It is always easier to make judgements when the work is seen together in various stages of development.

When making my work I do not have a preconceived idea of what the finished piece will look like. As soon as I make a mark or place a colour, then a painting has its own life and makes its own demands, and it is my concern as a painter to respond to those demands. I believe that it is important for me to discover my

Left: **Perugia Layers** 2010 watercolour & gouache
25 x 25cm

Right: **Wall Marks** 2012 watercolour & gouache
36 x 36cm

Right, below: **Towards Blue** 2013 watercolour &
gouache 15 x 15cm

own technique, to say my own thing.
I strive always to keep the door to
discovery open, believing that 'not
knowing' is an important prerequisite
for creativity.

Back in the 1960s I attempted to
do what the Abstract Expressionists
were doing, but I soon realised that
I was attempting to tune into these
artists' mature work. I needed to
go back to the drawing board in
order to find my own route towards
abstraction. I am still on that journey
and I know that the key to the route
that I want to take is simplicity.
Paintings are a series of colours,
directions and marks, and keeping
this as my focus whilst striving, as
Bonnard did, 'to give life to painting',
is enough for me. My journey seems to
be more uphill than ever. The search
is more challenging, but if I can keep
on the right road I know that the
rewards will be greater.

Peter Quinn

Painting starts with a walk. Walking is suitably slow: bicycles or cars speed you to your destination too efficiently. The walk might be pre-organised and follow a set route; I may have done some research and have notes and a map with me. More likely the walk is more like a meander, a stroll with some purpose and the subject matter of the painting is something discovered en route. I will have a small sketchbook with me and a camera. I may use paints but more likely pens or an automatic pencil, to scribble an impression. I use a digital camera and take many photographs to aid recall and to give some idea of colour, texture and detail.

The painting is assembled in the studio where there are preparatory drawings and false starts. I tend to work on several paintings at once, moving them on and off a high work table. I stand to paint. Some things I keep the same: the paper for instance, stretched on a board with a clear edge ruled at the sides. Other aspects of painting I change so often that I really do not have any set way of getting from the beginning to the end of a painting. Watercolour paintings disclose the history of their own making, the uncertainties, corrections and serendipities.

A few years ago when searching through a family collection of slides, I came across a photograph of myself aged about three standing in front of a canvas on an easel. My grandfather took up painting seriously in his retirement; my three-year-old self is hard at work amending one of his

paintings. I have dipped a brush into some very liquid paint and have made several abstract gestural marks over my grandfather's carefully-wrought Galloway landscape. Was this forgotten afternoon painting in the sun a long-lost beginning, a secret memory of the magic of watercolour?

Watercolour painting is a swell thing to do, to misquote a late, great American artist: 'It seems to be almost impossible to do it as well as maybe half a dozen blokes have in the past. I'm talking about skill and imagination that can be seen to be done.' Yet we keep trying. We live in complex times and there is no one secret formula for making a painting.

Perhaps the secret is that, as another American once said, 'a painting is not made with colours and paints at all. I don't know what a painting is; who knows what sets off even the desire to paint? It might be things, thoughts, a memory, sensations, which have *nothing* to do directly with painting itself. They can come from anything and anywhere, a trifle, some detail observed, wondered about and, naturally from the previous painting. The painting is not on a surface, but on a plane which is imagined. It moves in a mind. It is not there physically at all. It is an illusion, a piece of magic, so what you see is not what you see.'

Far left: **Canonbury Square Gardens** 2012 watercolour 70 x 83cm

Left: **Dog on Balcony, Marsaxlokk** 2009 watercolour 120 x 145cm

Above: **St Martin's Theatre** 2012 watercolour 75 x 97cm

Mark Raggett

I was born and grew up in west Wales, so the Pembrokeshire coastline is a constant source of inspiration for me. I now live and work in London and am inspired by the architecture, particularly along the banks of the River Thames, where the river craft and bridges provide dramatic subject matter. However, it is rural landscape which really fires my creativity and I find myself returning to Pembrokeshire for inspiration, exchanging an often claustrophobic urban environment for the vast expanse of sea and sky.

The clarity of light in west Wales is exceptional and I tend to go for long walks along the coast to soak up the atmosphere; particularly in early spring and late summer when the sun is casting long shadows. I am also drawn to other similarly remote and unspoilt landscapes such as Cornwall, north Wales and the Lake District, where one can experience the elements in the extreme. I find a wealth of visual stimulation in these remote places: in the rock formations, the dramatic contours of the land and the various colours and textures of the vegetation.

I record my experiences in small sketchbooks, mainly using pen and ink and graphite. I have accumulated many of these over the years and frequently return to this visual archive as inspiration for new work. I try to keep the sketches as simple as possible in an attempt to capture the immediacy of the scene. I don't dwell on them as they merely serve as a record; the germ of the idea, rather than finished pieces in themselves. I also support these with many photographs which serve as an *aide-mémoire*, rather than as images to be reproduced on the canvas.

On returning to the studio I transfer all of this gathered information into the work. After stretching the paper onto board with gummed tape, I quite often add

Needle Rock

Left: **Needle Rock (Dinas Island)** 2012 pen & ink, watercolour 52 x 32cm

Right: **Ar Lan y Mor** 2010 mixed media 48 x 58cm

Below right: **Carn Trefeiddan** 2011 pen & ink mixed media 50 x 65cm

some washes of colour or random brush strokes and spattering to give a basic texture. Once dried, I usually supplement this with cut-out pieces from magazines and journals, which will help further enhance the texture of the image I am trying to create. I then draw quite freely from the pen and ink study I have recorded in the sketchbook. As the composition evolves I erase and redraw constantly until I am happy with the overall effect, adding the paint (watercolour or acrylic) constantly during this process and keeping the many different elements alive at the same time. I paint in a gestural way and use varied brush strokes to evoke a feeling of place through movement and texture, shifting elements around the canvas and exaggerating the colour palette. The aim of the method is to create a more substantial 'whole'. The work gradually evolves in this fashion and by the final stages I find it is dictating to me rather than me imposing my preconceptions on it.

Quite often the work will appear totally abstract, but there are always figurative elements to be found somewhere to provide something to latch on to. My hope is that it will trigger the same emotional response in the viewer that I experienced when initially creating the image.

Stuart Robertson

I spent over seven years of my art career living and working in India. This has proved to have had a lasting influence on my work and I continue to visit regularly. The most important aspect in my work is drawing. I would have been content to draw and therefore explore the challenges that it brings, however, my time in India introduced me to colour. India is, in my eyes, the best country in the world in which to enjoy and be blown backwards by the experience of colour.

Travel is the best way to occupy one's time, and it is where the majority of my inspiration comes from. I take notes, draw and paint on site, which is where I am happiest. I am also deeply inspired by exhibitions of paintings by other artists. After viewing an exhibition I invariably experience a compelling urge to paint. The most treasured pictures to me are drawings by war artists. This particular period grasps my interest as it suggests a different approach, especially for works that are completed on site. Picasso's linocuts would also be on my list of favourites.

While working in my studio I am usually surrounded by plenty of images, some related to the work I am doing at the time, and others seemingly totally unrelated, but all have a certain ingredient that will draw me along. I am usually working on two or three paintings at the same time. There are two clear styles to my work. One is drawing and painting on site and the other is studio work. The studio work evolves with drawings in the sketchbook. I have many of these and I work constantly in them. I take photographs, make drawings and collect as much associated material as possible that I sometimes incorporate in my work, bus tickets, entry tickets, newspapers and the like. These add a visual and tactile aspect to the work, especially when I look back having left the place. I feel it is important not to be a slave to the camera, so the more I get from my drawing the better. I begin by formulating an idea in the sketchbook with on-site drawing and any material gathered. I spend time on the composition which I find most important. I tend to solve several problems at this stage, while allowing a degree of experimentation along the journey. I have a strong view that experimenting is crucial: it makes you less complacent with your approach.

I don't have a favourite paper, as different papers give different effects, and I like to take on a broad selection. I stretch paper before working on it as I tend to work over and over and change my mind and approach to certain areas of a painting. The paper has been known to tear and break up as I do this and I have lost many a painting this way, but I learnt a lot and enjoyed the struggle: 'It is better to have loved and lost than never to have loved at all.' One of the reasons I work the surface to the limits is experimenting with colour. I will sometimes put pigment on, then change it completely. Watercolour will allow a little of that to happen. It is about taking chances and more importantly about asking questions. It is not the most safe or calculated way of working, but I do enjoy the fight by this approach. I do not know what point the painting is going to arrive at, which is also part of the fun. In the studio I have a huge range of material I like to experiment with: gold leaf, ink, watercolour, pens, painting equipment; this is always ongoing. I go into art suppliers and buy materials I have never used and try them.

Left: **Mhandi 3** 2012 watercolour, collage & gold leaf
100 x 53cm

Below: **Sketch book drawings** rest of caption,
dimensions, medium, etc.

Bottom: **Varanasi 1** 2007 watercolour 16 x 42cm

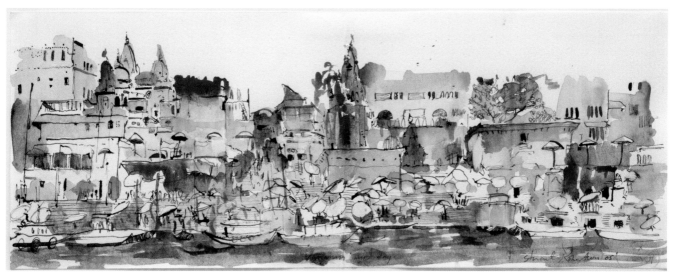

James Rushton

When I was a young student at the Burslem School of Art I came across a book called British Romantic Artists, *published in 1942. The author was a man named John Piper, unknown to me at the time. This book had a profound influence on me. It introduced me to artists like William Blake, Thomas Girtin, Samuel Palmer, J.S. Cotman and then on to D.J. Innes, Paul Nash and Graham Sutherland.*

I particularly remember a watercolour by Nash called *Spring at Fawley Bottom,* so fresh and direct and, at the same time, strange. This painting set a benchmark for me for years to come. It made me realise that watercolour painting was not just a way of recording observable facts, but was also the ideal medium for realising special moments or experiences in one's own life. There were of course other later influences, but this little book was the first and most compelling.

Someone coined the phrase 'the spirit of the place' which Samuel Palmer and Nash did so well. This, I decided, was what I wanted to do, but how do I evoke a childhood memory of the scent of honeysuckle or the drone of insects in a shady lane? Not easily, but I thought by drawing or painting I could come close.

At about the same time films were very much a part of my life – the black and white Hollywood films of the 1940s, and also the work of Powell and Pressburger. It is interesting to note that Powell and Nash were both influenced by the Surrealist movement but never a part of it, and this accounts for similar elements in their work.

Powell made an atmospheric film called *I Know Where I'm Going,* known as *IKWIG* in the trade. In September of 1946 it took me to the Isle of Mull where, less than two years before, the film crew had left the island and the locals were still talking about it. The film was made in black and white

and beautifully photographed by Erwin Hillier. I was not disappointed by the reality and have since spent many hours on the island with my watercolours.

I have not always been very particular about the quality of paint, brushes and paper, relying mostly on whatever was at hand but, on the occasions when I have taken the trouble to improve the quality of my materials, it has always paid dividends. If I am painting outdoors I prefer to use a tough heavyweight Bockingford as it needs no stretching and withstands harsh treatment. I am sure there are more diligent and knowledgeable painters who have better advice to offer than this.

During the late 1940s I was fortunate enough to be tutored by Alan King, a sculptor and contemporary of Henry Moore, at the Royal College of Art. He was a man of many parts, not the least of which, for me, he was an extraordinary painter in watercolour. He taught me the value of form, which I think is an integral part of good work and hopefully reflected in my painting.

Top left: **Black Mountain** 1997 watercolour & body colour 40.5 x 30.5cm

Left: **Near Malpas** 2004 watercolour & body colour 40.5cm x 30.5cm

Right: **Wildboarsclough** 2008 watercolour & pastel 43 x 33cm

Denis Ryan

I work from my own photographs; the urban environment offers me a lot of raw material. The current neon series has the metal, glass, stainless steel and strong colours that I find both a pleasure and a challenge to paint. I hope the strong composition and my palette, along with the interesting light sources, which play a pivotal part in all my paintings, create the desired impact, producing a painting full of visual excitement.

I was born in London and studied for an MA in Fine Art Painting at Watford, Hornsey and the Ravensbourne Colleges of Art. I also have a university degree in Art Education. My career began in film animation and, later, illustration, successfully combining both in my work on award-winning films as well as numerous TV and film commercials.

I am now painting full-time from my studio at London Bridge. I exhibit at the RWS and have also exhibited at Cork Street, the Royal Academy, Mayfair as well as internationally in Italy, China and the USA (Charleston, Texas and the OK Harris Gallery in New York).

I fill notebooks with sketches and ideas on my travels, collecting collage material and taking many photographs. I have a strong emotional attachment to the city and the recurrent motifs in many of my paintings reflect this, particularly my recent series of neon signs.

I combine work in acrylic (Liquitex) and watercolour (Winsor & Newton) using the finest sable brushes of varying sizes and working on Saunders-Waterford paper mounted on board to avoid any unnecessary movement. I begin each painting with a very detailed drawing which gives me the chance to really get to know the geography of the subject so that when I reach for my brushes I know every nut and bolt of what's where. I use acrylic and watercolour in exactly the same way and build up each painting with a series of thin transparent washes to achieve the maximum amount of vibrant colour I require.

My love of abstract painting is reflected in my use of colour. I know my colours are more saturated than the usual palette of realist artists. I think being surrounded by colour in film animation for years must have had a subconscious effect on me: I don't set out to make colourful paintings, it's just the way I see things.

There is a long and illustrious history of watercolour painting in Britain and I was delighted to be elected to the RWS in 2008. I feel that my technique and approach to painting have improved immeasurably since I was elected. The feedback, ideas and encouragement from other members is terrific.

Above: **Neon Café Portugal** 2010 watercolour 34 x 34cm

Top right: **Clear Neon** 2012 watercolour 19 x 28cm

Right: **Road to Damascus** 2012 watercolour & acrylic 34 x 56cm

William Selby

I find a lot of interest in working in different media, exploring different ways with oil, acrylics, watercolour, tempera, etc. I just love handling any form of paint on a variety of surfaces.

Nothing exotic in subject matter, the landscapes are usually Yorkshire, the Howgills and the Three Peaks. The starting point for a still life is often the title, *The Moon & Sixpence, Dandelion & Burdock, A Spoonful of Sugar* and so on: simple titles that can have so many interpretations, executing in a free and painterly manner whilst exploring colour and paint surface.

Being very critical of my own work, I never seem to be completely satisfied with the end result – perhaps one day.

Left: **The Moon & Sixpence** 2012 mixed media 53 x 43cm

Above: **Rose & Crown** 2012 mixed media 25 x 20cm

Right: **Rose & Hips** 2012 mixed media 62 x 62cm

Agathe Sorel

I have been drawing and painting ever since I can remember. At art college I concentrated on graphics, stage design, anatomy and perspective, but watercolour seemed the fastest way to take notes. Later the notion of line in space started to interest me, leading to three-dimensional works in acrylics using industrial techniques.

In my recent watercolours I try to combine a variety of techniques on a fairly large scale. The impact of colour seems to be more powerful and increases with size. It also allows a larger playground to work in.

Whereas the first studies are usually small, painted in the landscape at the quick of the moment, the large watercolours need calmer conditions in the studio.

I am experimenting all the time and trying to respond to the marks and colours emerging on the paper. Planning is restricted to compositional diagrams, but these are often superseded by a dialogue taking place as spontaneous events unfold. I frequently use masking fluid to preserve the freshness of the paper as well as using collage or decoupage, which introduces new possibilities to the composition. The process is always different and sometimes drastic changes take place when the painting is scrubbed down in the bath, abraded or built up. I use natural materials like leaves or bits of loofah dunked into a resist to preserve the pristine quality of the paper; this creates a dramatic effect with the bold washes painted over it. Water spray or the hairdryer could also be used to introduce a flow or movement to the picture.

I quite often use spray techniques, using manually operated spray bottles, with lightly diluted watercolour. The resulting slightly blotchy but flat surface contrasts well with the

Far left: **Pottery Village near Kujarajo** 2007
watercolour 676 x 553cm

Left: **Blue Acrobat with Shadows** 2011 watercolour,
collage 460 x 680cm

Below: **Pink Acrobat and Audience** 2011 watercolour,
collage 460 x 680cm

calligraphy of the brush work; it also introduces a different perspective. One can use the spray in a directional way, giving the impression of fairly realistic three-dimensional objects being lit from behind. The use of ordinary recognisable objects often adds a sense of reality to an otherwise abstract composition.

Sizing the paper thoroughly on both sides is very important in order to keep flexibility and to keep the options for spontaneous changes.

The painting is floated when framed, so as not to lose the deckle edges.

Although I am not painting from photographs I am using photographic and digital processes increasingly to capture the detail I am working on, to manipulate the tones or simply to print out my compositions. This does not result in photographic work. On the contrary, it seems to loosen up the process.

As an engraver and sculptor I was mainly influenced by Surrealist and Constructivist artists like S.W. Hayter, Naum Gabo or Laszlo Moholy-Nagy. Now that I concentrate on watercolour painting I am more influenced by Matisse, Bonnard, Picasso, Gustave Moreau or Rouault on the European side, but also by American abstract expressionists like Jackson Pollock, Robert Rauschenberg or William de Kooning.

I am not interested in making elegant paintings, but to see how far I can go with an individual work.

Richard Sorrell

Technical accomplishment or even beauty should be the servant of the spiritual meaning of all art, and this applies equally to watercolour.

The big problem with watercolour is that it seems to be so final. If you make a mistake, you ruin your work. If you are always trying not to make a mistake, your picture will look timid and feeble. So you are going to make mistakes. Here is how to get rid of them.

Sponging: take a sponge with a little water in it and rub it over the area you want to remove. If the watercolour is less than a week old and the paper is not too soft, the paint should come off. Dab the surface of the paper with some absorbent white kitchen roll to take the water off. If you have rubbed too hard, the surface of the paper may be spoilt and when you go to paint on it next, it will be like painting on blotting paper. To cure this (to some extent) you could paint the surface with some diluted gum arabic and allow it to dry. Alternatively, take a natural sponge with a little water and gently touch the surface of the paper. Dry it immediately with some kitchen roll and rub it over. You should find that a random pattern of specks has been removed. This can be painted over with a wash and painted into with a small brush. Sometimes this is useful if you are painting foliage or distant trees.

Acetate stencils: if you want to remove a precise area of a watercolour, place a sheet of acetate

over the dry picture and draw the shape with a fine permanent marker. Then remove the acetate and cut out the shape with a sharp craft knife. Put the resulting acetate stencil back over the picture and sponge through it with a not-too-wet sponge. This should give you a light area with a clear, sharp edge.

Highlights: take a small brush dipped in water and paint it on a small area of dry paint that you would like to be lighter. Dab it dry immediately and rub it with an eraser. This should remove the paint back to the paper. You will almost certainly need to paint or wash over this area to take away the starkness of the contrast. Alternatively,

pick out tiny specks of light with the tip of a Stanley knife blade. If the paper is very tough, it will take a lot of scratching back, and this can be useful when painting rough stonework or tree trunks.

Body colour is so called because it has body or heaviness, as opposed to transparent watercolour. The most commonly used body colour is gouache or opaque watercolour. Gouache can be painted over in a technique akin to oil painting. It can also be used in conjunction with watercolour to give greater weight to an area or (when used thinly) to make hazy, misty effects. Like watercolour, it can be used in a dip-pen to make

sharp lines or points of colour. (Mix the colour up thinly with a brush and paint it onto the nib.)

Acrylic paint is not dissimilar to gouache, but it is waterproof and cannot easily be rubbed back. It is versatile, and it lends itself well to the transparent techniques of glazing (a thin coat of dark colour over a light base) or scumbling (a thin coat of light paint over a dark undercoat). These methods help to overcome the unattractive hardness of the edges that is one of the problems of acrylic. Acrylic inks are powerful colours that can be painted or used in a dip-pen. Areas of an acrylic painting that are unsatisfactory can be obliterated by

going over them with acrylic primer, and one is back to the start again.

Casein paint is sold under the name Plaka. It is similar to gouache, but much harder. There appears to be a limited range of colours, but small amounts can be mixed with watercolour, and watercolour can be painted over it. Casein paint is useful for a broad approach and is quick to use and quite versatile.

Pastel is pigment mixed with gum arabic and rolled into dry sticks. It can be drawn over watercolour, and if thought appropriate, washed over with water, when it becomes a kind of watercolour. Light-coloured pastels can be used to make highlights.

Watercolour pencils are useful fairly recent inventions. If you want to draw guidelines for a watercolour painting, draw them lightly in a light grey watercolour pencil and paint up to and over the line. It will be taken up into the wet paint and completely disappear, and this makes painting two washes of colour next to each other much easier

Left: **Hair Dresser** 2007 watercolour 51 x 72cm

Above: **The Company of Extroverts** 2008 watercolour 56 x 76cm

Janet Q. Treloar

Perhaps the medium of watercolour chooses one, rather than vice versa, and sometimes circumstances make it an inevitable choice. This was certainly so in my case. I had a peripatetic life for more than 20 years, in which the continual travelling made watercolour the only choice. That, and my love for Turner's sketches from an early age, though growing up in Cornwall I only saw them in books.

I was constantly sketching in different environments: in Libya, Kuwait, the Colombian Andes, and then for eight years in Norway. Being more settled, it was there that I made the transition from amateur to professional. This was due in no small measure to Don Dennis, a brilliant watercolour teacher from America. Not for him the often pale intimacy of the English tradition, but rather the boldness, dramatic and sublime, of Sargent and Winslow Homer. He gave me three 'secrets'.

The first was always to use the best paper. I went from cartridge paper to Arches 300gsm paper in big sheets, not a pad or a book, and it was a revelation. It takes fabulous washes. Good quality paper can be pushed around, indeed bullied more than is realised, a bit like playing a cello instead of a violin.

Second, to use masking tape to anchor all four sides of the paper to a board. No more soaking or stretching needed and one can tip the board and direct big washes right up to the edge of the paper and beyond. When finished and dry, the masking tape is taken off to leave a sharp white edge.

Third, to use a large, folding metal palette with a thumb hole, and squeeze out the colours in order, dark to light, from tubes (I prefer Winsor & Newton, especially their yellows, and I keep the paints moist after use with cling film). Not only do the tube colours seem more intense than their pan equivalents, but this enables me to be more aware of overall tone and colour. With the palette held higher and nearer the brushes I can better coordinate the whole process and move beyond the mindset of the sketch. I find these methods enable me to paint free of the tyranny of line and to enjoy my washes, the wet or the dry paint, and to exploit those accidents that happen in that elusive way that is 'chance not choice'.

This all combined to show me how to use my sketches for finished work, which led to many successful exhibitions and to being elected a member of the Kunstforeining of Norway – perhaps not least because I used to go out to the hills and fjords in all weathers with my paints and sketchbook, and I never met a Norwegian painter who left the studio!

Returning alone to London, I had to think hard about what direction to take. My decision to stick with watercolour and work on paper had something to do with temperament and also with money. A separate studio was expensive and watercolour is easier than oils to work with at home, but above all the medium suits my nature. I like to work fast under pressure and to be decisive. I am too impatient and intense to spend weeks at a canvas: is there such a thing as emotional time, different from real time?

Left: **Church at Aleyrac, Provence** 2004 watercolour

Right: **Hand to Hand Fighting, Stalingrad** 2005
watercolour 55 x 74cm

I love history and have a constant sense of the reality of the past. This, together with my love of church hopping, led me to the idea of the 'Romanesque Arch as a Visual Language of Europe' – from Sicily to Norway and from Scotland to Croatia. This idea was behind my travels, my work and my exhibitions for some ten years until, in the winter of 2004, I was inspired by a different theme: Russia, particularly the war sites. I used the same trusted medium of watercolour, for I could carry only a minimum of paraphernalia, and one has to be able to work fast indeed when standing in deep snow with the watercolour freezing as it hits the paper! Following several trips, I worked up my sketches into bigger and denser paintings, still in watercolour, for I believe the medium is as able as any to bear a full charge of emotion. Exhibitions and books followed on the resistance of 'Russia's Hero Cities 1941–45', and the parallel resistance to Stalin's terror of the great poet Anna Akhmatova.

Perhaps we all feel the need to make the personal more permanent. Motherwell and Pasmore, for instance, constantly refer to seeking the ephemeral and personal moment and rendering it archetypal: to nail that moment in the instability of time in which we live. Watercolour is particularly good at this. Like Helen Frankenthaler, I feel that 'paper is painting' and to try to articulate a language so that it functions as both subject and object is immensely challenging and rewarding.

Alexander Vorobyev

My voice of originality speaks about dreams, struggle and conflict, politics and ideology, nature and the absurd.

I experiment with dreamscape and ideas and my watercolours display a calculated compositional approach yet seem to flow with automatism – a complex mix of texture and forms displaying my unique symbology. The viewers journey around my works, always finding new meanings the deeper they look.

Inspired by Arthur Rimbaud's comment 'chaotic nature of thought is sacred' – it is through this pilgrimage with my stream of consciousness that I break through to the other side of perception, and new meanings are delivered through my works.

I am fascinated by the concept of the cross: it is my childhood again – with crosses of window frames of old houses, masts of ships, it is a handle of a sword, medieval Europe, crusaders, a razor blade; it is a battle, a struggle of the vertical and horizontal lines, of the spiritual and the material worlds. There is something magical at the moment of a collision of the vertical with the horizontal – when you are neither awake, nor in deep slumber. There is a distinct spark emerging during that interwoven contact in the middle of that crossover. And that is the moment when I receive the gift of an image, an idea, a whole composition, or just a few words for a clue. Crosses appear as mosaic-like backgrounds, clasped in hands,

intertwined with forms or scattered across a composition.

I am interested in texture and learn about it from live and dead nature. Be it the bark of trees or wings of butterflies, or rotting flesh of fruits. I often use flower pollen and rub it into the paper, use aloe vera plant or pomegranate juice or even my own blood if I happen to cut my finger in the process. This way I become an artist who mixes his blood with ink.

Typography is everywhere, tumbling letters, people's names,

Left: **Still Life with a Head on a Blue Dish** 2000 mixed media 44 x 34cm

Right, top: **Mechanisms** 1994 mixed media 45 x 35cm

Right, below: **Funeral of a Butterfly** 1998 mixed media 23 x 33cm

words, sentences, newspaper clippings and whole written out paragraphs inside and outside of the main compositions.

Dust is gold. I call on dust to become my ally, my co-author. I even leave my watercolours horizontally on the floor, so that the pores of my specially created texture absorb as much dust as possible. Complex texture works as a trap for insects and dust, so I carry on mixing watercolours with insects and dust. Eventually, the surface starts to live its own independent life – a tiny midge crawls onto the surface, or a fly lands right on an object which attracts it in the watercolour, so I expertly manipulate my brush and pin it onto the paper. Some of the insects have just visited the magnificent flowers outside and now they carry on drawing on my watercolour, creating their amazing trajectories, seen only by me, continuing my own lines and adding to my colours. O summer and sun, bless you!

I am fascinated with shapes and use plains of textured colour broadly. I am preoccupied with mechanisms, they turn up as small drawings or as working parts of mechanical characters.

I use animal symbols – terrapins, snails, bats, horses, embryos and insects often intertwined with human forms.

I am fascinated by the anatomy of magical and almost alien insects and they metamorphose during their life cycle.

Horses are often depicted with a riding warrior figure, they represent battles.

Terrapins and snails represent hardness on the outside with a soft vulnerability on the inside. Severed limbs or objects represent pain.

Life itself inspires me, in all its beauty and horror! Ideas for my pictures spontaneously come to me in my dreams. I know a legend about an eighteenth-century English poet who had a dream one night of being in a mysterious place and when he woke up, he had a flower in his hand; a flower from the place that he saw in his dream! Ideas or whole compositions come to me in my dreams – I would compare it with that flower in hand. Life is a mysterious procession.

Ann Wegmuller

Although my paintings are an abstraction of what I have seen, they are still firmly based on the visual world around me. I live in the country and it is pools of water in furrows in winter fields or unexpected clouds hanging over a river that make me want to paint. In the summer I try to get to the seaside as soon as possible and the pleasure of walking on the beach gives me a lot of material for my work.

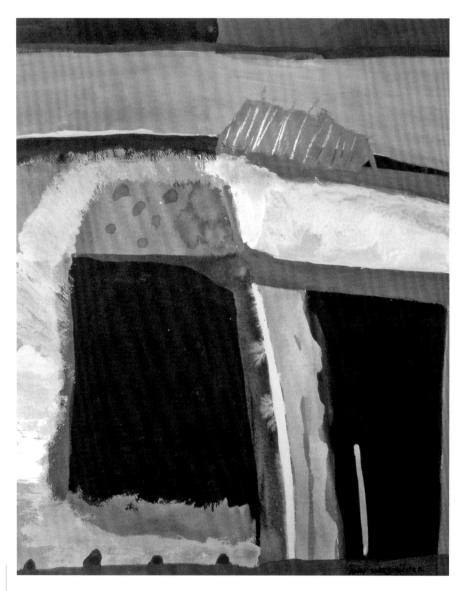

Sometimes I do drawings, but I find that generally I do not sketch or take photographs. I try to keep the image in my head and this way I find I automatically edit out what is not important to me before it ever reaches the paper.

There are no short cuts in painting of course, and working this way means that I have to have various sizes of paper stretched and ready as I have to work quickly to put down what is in my mind's eye. The best paper for me really is paper that does not have to be stretched at all.

To create a mood for my work, I use colour, the darker cooler colours for winter and the hotter colours for summer. This may sound like a simplistic approach, but the results of working like this can be quite fascinating. A little warm colour in the cooler, winter paintings brings out their true value, like the wonderful rust of dock seeds in the snow or the pools of blue water amongst the hot rocks of the beach in summer.

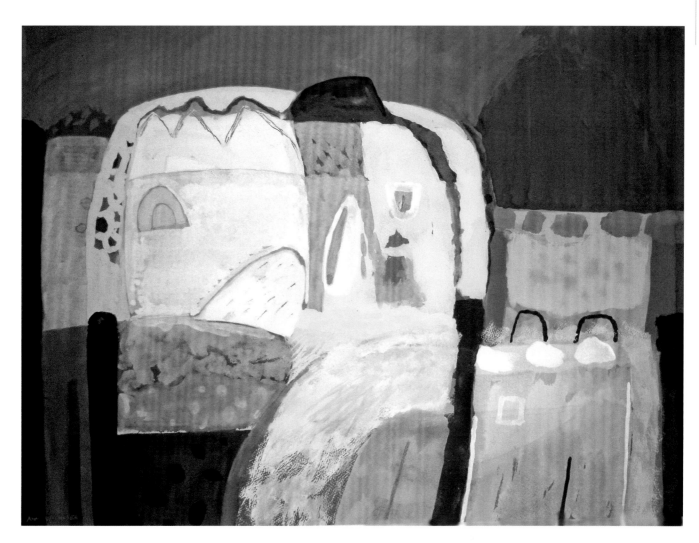

This can disturb the whole feel of the painting, as these colours suddenly become the unintentional subject, and it is where the real struggle to paint what I want to say begins. I do not have titles for my paintings beforehand, but I do know their season and where I was when I had the urge to paint.

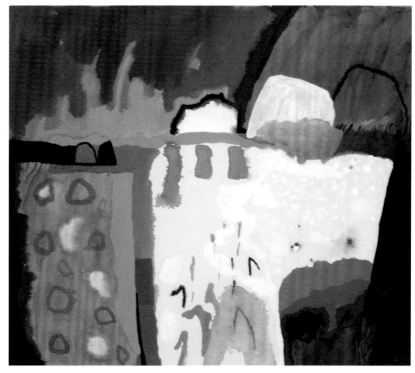

Left: **Perthshire Winter** 2008 gouache 51 x 41cm

Above: **Shore Uncovered** 2003 gouache 54 x 75cm

Right: **Summer Sands** 2010 gouache 64 x 74cm

Jenny Wheatley

I do not consider myself a watercolourist, but a painter. The starting point for a piece of work is always what I am trying to say about my given subject. Once I have identified the reason why I want to make that painting, and the emotive elements of it that I wish to try to portray, I then pick up the tools that I feel can most easily put that message across, be they oils, acrylics or watercolour, each with their essential and seductive qualities.

If choosing watercolour I would be wanting to celebrate its glory of soft, glowing colour, the delicate overlays of layer upon layer of juicy pigment, where colours can shine through and create a history by their pigmentation, granulation and passage of time. An image that would make me reach for my watercolour paints rather than any other medium would be one that requires a merging of soft layers of colour and a glow that appears to come from behind the paper, supported by later more specific and decorative marks that will convey depth as well as the history of each particular brush itself.

I am no purist. I want the paint, the brushes and the paper to work for me and the subject. I see no point in torturing the medium for the sake of rejecting other water-based media in the process. Therefore I experiment constantly and keep records of all the things that went wrong (and there are many!) in one painting, as they could well be the mark that is needed in another. I use traditional watercolours but also make my own using pigments and an arabic-glycerine mixture. This means that I can make the paint thicker or thinner in texture, coarser or finer by grinding, and therefore extend the surface as a result. I use a wide range of colours to try to make

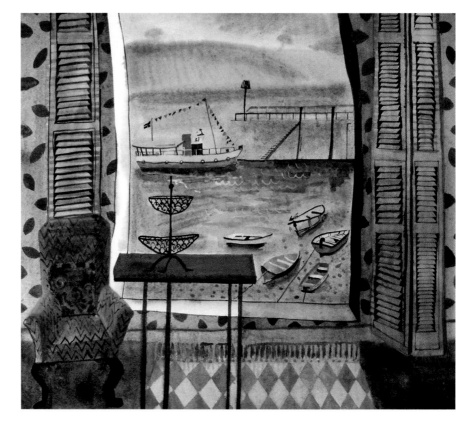

close tone, glowing and rich colour mixtures. I use white body colour to make paints more opaque where necessary and a wide range of brushes to make different marks. I use both ends of the brush so that I can scratch into the paint. I use sponges, cloth and paper or cardboard masks to remove areas of paint as well as to apply them, and the capillary action of the brush to lift paint where it is needed. I also use a wide range

of papers, both hand- and mould-made, and like to celebrate the rough deckled edges of handmade paper by treating the finished paintings as objects, float-mounting them like pieces of rich material.

I paint both very large and tiny pieces. To me, scale is again dictated by the single element that I want to elicit from that particular subject at that particular time. To me, a monumental painting can be five

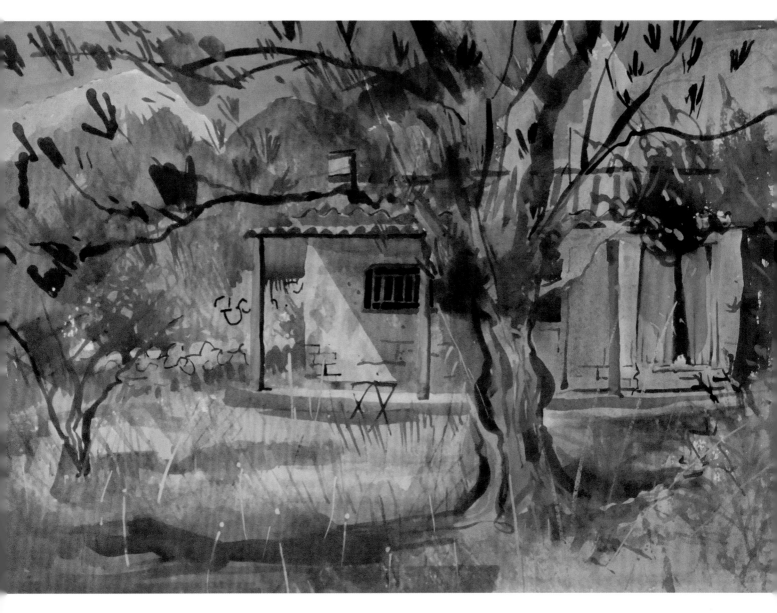

inches square as well as seventy; it is the message and intent enclosed in it that will give the scale. Likewise with drawing. I believe that drawing and painting are an attitude and a manner of working rather than separate entities. My paintings contain both. One can paint with a pencil and draw with a brush; it is the mark that dictates the name of the activity.

Each time I pick up a brush and any medium I have no idea if the thing will work in part or in whole, but with my intention firmly established I need to give it a go or I will never find out. Every piece is an experiment and a process of learning that leads to the next piece, and so on. Here we return to the beginning. For me it is all about what I am trying to say in each piece, and if I want to say more than one thing then I will do more than one painting of that subject, often in different media each time as the intent and the atmosphere dictate. This is why I consider myself a painter and not a watercolourist.

Left: **St. Mawes Ferry** watercolour 63 x 71cm

Above: **Shelter** watercolour 38 x 56cm

Michael Whittlesea

I have used a variety of materials over the years; it's useful to try out a wide range of paints and paper to discover their potential, as it helps to then choose the materials that are of particular use to my way of working. Using inferior paper and paints is false economy. Artists' materials are expensive and so I limit my range of colours to perhaps eight, all of good quality. Choice of paper is important. I use a NOT cold-pressed paper; it has a slightly rough surface. I use tubes of watercolour, not pans or cakes or even watercolour boxes. They all look nice, but they don't suit my way of working. I squeeze colour out onto a collection of large old dinner plates. I use plenty of fresh clean water which I change constantly.

The subject matter of a painting is very important to me. I choose to paint things I know well. Rejecting the idea of painting, for example, Venice. It's a wonderful city, we all know that. I don't see how any painting that I attempt will show anything new about it, or be more interesting than all the paintings done over the years by some of the greatest artists. I feel the same about painting children or an attractive girl. They are delightful, but I would rather choose to paint an old person who has years of interest etched into their face.

A blank sheet of watercolour paper can be quite daunting. To overcome this I use a soft pencil to simply indicate the main points of interest in the painting. I like the idea of geometry in making pictures. It's a very traditional method: a simple division of the picture area. Not, for example, putting anything too dominant that will divide the painting into two equal parts, or leading the eye off the edge of the picture. I try to place at this early stage what I think is the main interest.

The 'drawing in' is kept simple and not done in too much detail because I also like the unexpected when I paint. All this early planning is often rapidly re-assessed when painting with watercolour and the unexpected happens. If the drawing is in too much detail there is a danger of the painting becoming rather like a colouring-in book.

Working on four to six paintings at one time allows me to leave washes to dry before working over them and it also stops me 'overworking' any one picture. They are laid flat to work on and to dry.

If I am not happy about the early progress of a painting, I wash it out, using sponges. It's risky, but the result can be softer and unexpected. I can then work on it over and over again. 'Accidents' are an important element of my work. Being able to recognise a good accident when it happens is vital. And then, knowing when to stop is even more important.

Left: **Portrait of an Old Lady** 2010
watercolour & pencil 46 x 32cm

Right: **The Barn in Winter** 2012 watercolour
& pencil 43 x 53.5cm

Below: **The Garden in Winter** 2012
watercolour & pencil 36 x 56cm

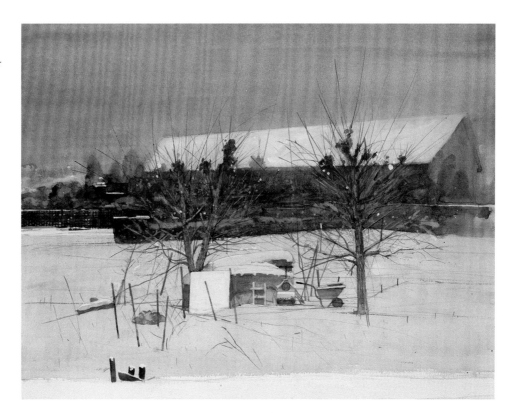

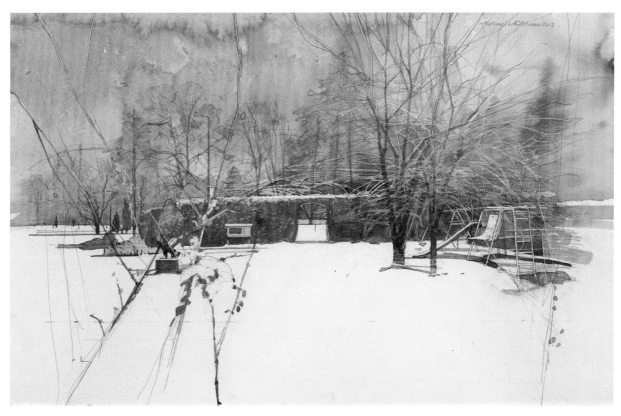

Annie Williams

In the last ten years my paintings have been almost entirely based on the still life. This has given me the freedom to combine working in abstraction and reality, and for me, both rely on the importance of looking and drawing.

I have been working in both print and watercolour since the 1980s. Both can still give me the excitement and element of surprise. In watercolour the building up of colour and washes can have beautiful effects.

The setting up and arrangement of the composition is all-important to the success of the painting and is worth spending time on. I work with side-directional light so shadows become part of the composition.

I have a pinboard at the back of my painting table, and my chosen objects are arranged on a box in front of this. These objects are often quite small, so that a good deal of my paper is taken up with the background. This is usually a collage built up from torn papers from magazines, doodles I've painted on scraps of watercolour paper, occasionally bits of fabric and old postcards etc. It also involves quite a lot of imagination, as I often simplify and alter what I see in front of me.

I am obsessed by light, form and colour, and my quite large collection of small pots is my first port of call. I'm always on the lookout for new and stimulating shapes.

I don't buy expensive brushes, but I am really particular about the paper I use. I really like the smooth hot-pressed hand-made RWS paper (300gsm), as it enables me to move the paint around and even wash areas out. I used to stretch it but now don't bother. I flatten it between heavy boards, in much the same way that I dry my prints.

When applying washes I always ensure that the colour is dry before painting another on top, to prevent it becoming muddy. If the background is too prominent, jarring or just not working, I often cover the whole with at least one wash, and sometimes paint out or alter whole areas using gouache. White gouache is very useful for highlights.

I'm ultimately trying to put down on paper something I find visually exciting – it certainly doesn't always work, but I'll keep trying!

Above: **Still Life with Two Hackney Pots** 2010 watercolour 40 x 50cm

Right, top: **Tickmorend Tapestry** 2011 watercolour 40 x 50cm

Right: **Variation on a Theme** 2010 watercolour 40 x 50cm

Charles Williams

I paint, rather than take photos, because painting allows me to improvise. My studio is a place for me to run with ideas and follow undefined feelings towards some kind of definition. I cannot really say what that is, other than a sense of recognition.

So, my chief studio rule is no sketches, no photos, no studies. Nothing. People seem to assume that the paintings come from somewhere, but I promise you, they are simply *à la tête*. I cannot be bothered with stopping and fiddling around with other things, looking at photos, or doing that projecting thing. How boring can you get! It seems to me that the artist's life is so painful, dull and unremunerative, you have to have somewhere where you are free to invent, to play, to experience, and of all places, shouldn't it be the studio?

I do draw a lot, and I look at other painters' work, because I learn from both these processes, but I don't want anything in the studio except my work.

It's difficult to persuade students of this, though. 'Where are the images from?' they insist. I don't know. My head. What do you have in your head?

Watercolour is a terrible challenge in this improvisation process. The artist I keep in mind is Nolde, with his 'forbidden paintings', and sometimes my paintings can get very thick, with layers of colour, one after another. A painting might take years to finish. The transparency of the medium means that the longer I work the darker the image gets – you can see that in these paintings.

I started teaching watercolour in adult education as a way of supporting myself when I was a younger struggling artist. It's the best thing to start with because you're never short of recruits. I thought that people would want to find their inner artist rather than learn techniques – that's how I was taught at art college, and I thought my adult education students would feel the same way.

I soon found out that they didn't, so I set myself to learn how to paint watercolours 'properly'. I bought all the 'how-to-paint' books I could find, in secondhand book shops, in Oxfam shops, in art book shops, and read it all up. I developed a great love of John Sell Cotman, such a wonderful, methodical, intelligent watercolourist. My classes swelled, and I became a sought-after teacher.

Left: **Mum's New Boyfriend** 2005–12 watercolour
12 x 7cm

Right: **Artist** 2008 watercolour 10 x 13cm

Below: **Giving and Taking Advice** 2007 watercolour
12 x 15cm

But as my teaching got better my work got worse, because, knowing what a good watercolour painting should look like, I became hugely self-critical. My plan chest filled up with paintings abandoned as soon as I had slipped, changed my mind, or gone the 'wrong way'.

It was terrible, but a good lesson. Technique is great and so is knowledge, but that's not why one does it.

Contributors to Watercolour Secrets

Abbreviations

ARWS Associate of the Royal Watercolour Society
NEAC New English Art Club
PPRWS Past President of the Royal Watercolour Society
PRWS President of the Royal Watercolour Society
RA Royal Academician
RBA Royal Society of British Artists
RE Royal Society of Painter-Printmakers
ROI Royal Institute of Oil Painters
RP Royal Society of Portrait Painters
RSW Royal Scottish Watercolour Society
RWA Royal West of England Academy
RWS Royal Watercolour Society
VPRWS Vice President of the Royal Watercolour Society

Artists

Diana Armfield, RA, RWS, NEAC
Fay Ballard, RWS
Charles Bartlett, PPRWS, Hon RE
Richard Bawden, RWS, RE, NEAC
June Berry, RWS, NEAC, RE, RWA
Akash Bhatt, RWS, RBA
Dennis Roxby Bott, RWS
Francis Bowyer, PPRWS, Hon RE, NEAC
William Bowyer, RA, RWS, NEAC, RP
David Brayne, RWS
Liz Butler, RWS
Michael Chaplin, RWS, RE
Helga Chart, RWS, RSW
Michael Collins, RWS

Jane Corsellis, RWS, NEAC
Clare Dalby, RWS, RE
Alfred Daniels, RWS, RBA
George Devlin, RWS, RSW, RBA, ROI
John Doyle, MBE, PPRWS, Hon RE
Jim Dunbar, ARWS, RSW
Anthony Eyton, RA, RWS, The London Group
James Faure Walker, ARWS, The London Group
Sheila Findlay, RWS
David Firmstone, MBE, RWS
Tom Gamble, RWS
Janet Golphin, RWS, ROI
Isla Hackney, RWS
Charlotte Halliday, RWS, NEAC
Susan Hawker, RWS
Julie Held, RWS, NEAC, The London Group
Bill Henderson, RWS, The London Group
Sarah Holliday, RWS
Ken Howard, OBE, RA, RWS, NEAC, RWA, RBA, ROI
Jonathan Huxley, ARWS
Wendy Jacob, VPRWS
Olwen Jones, RWS, RE
Janet Kerr, RWS
Sophie Knight, RWS
Karolina Larusdottir, RWS, RE, NEAC
Sonia Lawson, RA, RWS
Jill Leman, RWS, RBA
Martin Leman, RWS, RBA
Arthur Lockwood, RWS, RBA
Caroline McAdam Clarke, RWS
Angus McEwan, RWS, RSW

Colin Merrin, RWS

Michael Middleton, ARWS, RE

Bridget Moore, ARWS, RBA, NEAC

Peter Morrell, RWS, The London Group

Alison C. Musker, RWS

John Newberry, RWS

Paul Newland, VPRWS, NEAC

Barry Owen Jones, RWS, RE

David Paskett, PPRWS

David Payne, RWS

Simon Pierse, RWS

Richard Pikesley, RWS, NEAC

Geoffrey Pimlott, RWS

Neil Pittaway, RWS, RE

Thomas Plunkett, PRWS

Salliann Putman, RWS, NEAC

Peter Quinn, RWS

Mark Raggett, ARWS

Stuart Robertson, RWS

James Rushton, RWS, NEAC

Denis Ryan, RWS

William Selby, RWS, ROI, NEAC

Agathe Sorel, RWS, RE

Richard Sorrell, PPRWS, Hon RE, RBA, NEAC

Janet Q. Treloar, RWS

Alexander Vorobyev, RWS

Ann Wegmuller, RWS, RSW

Jenny Wheatley, RWS, NEAC

Michael Whittlesea, RWS, NEAC

Annie Williams, RWS, RE, RBA

Charles Williams, RWS, NEAC

Index